HOW TO START A PROFITABLE BUSINESS WITH YOUR SPOUSE

Build a Thriving Partnership, Balance Love and Success, and Achieve Lasting Financial Freedom Together

Jeanelle K. Douglas

Copyright © 2024 by Jeanelle K. Douglas.

All rights reserved.

DEDICATION

To the reader who holds this book. You hold the key to unlocking this journey.

Thank you for joining me.

Table of Contents

Introduction ... 7
 Why Start a Business with Your Spouse? 8
 What Can You Expect from This Guide? 11
Chapter 1 .. 13
 Laying the Foundation ... 13
 Assessing Your Relationship Dynamics 15
 Identifying Shared Goals and Values 18
 Establishing Communication Strategies 21
Chapter 2 .. 24
 Finding Your Niche .. 24
 Brainstorming Business Ideas 27
 Researching Market Opportunities 31
 Narrowing Down Your Niche ... 34
Chapter 3 .. 37
 Planning for Success ... 37
 Crafting a Business Plan Together 41
 Setting SMART Goals ... 45
 Creating a Shared Vision ... 48
Chapter 4 .. 52

 Legal and Financial Considerations ... 52

 Choosing the Right Business Structure 56

 Understanding Tax Implications ... 59

 Managing Finances as a Couple ... 63

Chapter 5 ... 67

 Building Your Brand .. 67

 Defining Your Brand Identity ... 71

 Developing a Marketing Strategy ... 75

 Leveraging Your Unique Selling Proposition 79

Chapter 6 ... 83

 Managing Roles and Responsibilities ... 83

 Delegating Tasks Effectively .. 86

 Balancing Work and Personal Life .. 90

 Resolving Conflicts in the Workplace ... 93

Chapter 7 ... 97

 Cultivating a Supportive Environment .. 97

 Celebrating Milestones Together ... 101

 Nurturing a Positive Work Culture .. 104

 Seeking Outside Support When Needed 108

Chapter 8 ... 112

Scaling Your Business .. 112

Scaling Strategies for Couples .. 116

Outsourcing and Delegating as You Grow 120

Planning for Long-Term Sustainability.................................... 124

Chapter 9 .. 129

Overcoming Challenges Together.. 129

Strategies for Resolving Disagreements 132

Strengthening Your Relationship through Adversity.............. 136

Chapter 10 .. 140

Looking to the Future ... 140

Setting Long-Term Goals for Your Business.......................... 144

Planning for Succession ... 147

Reflections on Your Journey Together 151

Conclusion.. 155

Introduction

This book is intended to be your guide and companion as you begin on the thrilling path of establishing a business empire with your spouse. Whether you're newlyweds with a shared goal or experienced spouses looking for a new adventure, this guide provides insights, tactics, and practical guidance to help you manage the unique obstacles and possibilities of entrepreneurship as a partnership.

In the following pages, we'll look at the subtleties of beginning and building a profitable company while maintaining a healthy and peaceful relationship. From setting the groundwork to growing your empire, we'll teach you all you need to know to run a successful business while enhancing your relationship with your partner. Throughout this course, we'll highlight the significance of clear communication, a shared vision, and mutual support in attaining your business goals.

We'll talk about how to use your individual and couple talents, overcome problems together, and celebrate successes in both your company and your relationship. Starting a business with your spouse is a unique and gratifying experience, but it also has its own set of problems. We recognize that each marriage is unique, and there is no one-size-fits-all strategy for business.

This guide provides practical advice, real-life examples, and effective techniques that you can adjust to your own circumstances and goals. So, whether you want to start a modest family business or conquer the worldwide market, this guide is here to help you every step of the way. Prepare to embark on an amazing adventure of love, cooperation, and entrepreneurship as you create your own business empire together.

Why Start a Business with Your Spouse?

Starting a business with your spouse is more than simply a professional effort; it's an opportunity to improve your relationship, create a shared legacy, and work toward common goals. While the concept of combining work and pleasure may appear overwhelming to some, there are multiple compelling reasons why going on this adventure with your life partner may be quite gratifying.

Here are the reasons:

Shared Vision and Goals: When you establish a business with your spouse, you align your professional and personal goals. You both have a similar vision for the future and the potential to achieve goals that are important to both of you. This alignment may give your partnership a sense of purpose and togetherness as you work toward a common goal of success.

Stronger Communication and Trust: Effective communication is the foundation of every successful relationship, and launching a business together gives several opportunities to hone this skill. To solve obstacles, you and your business partners must speak honestly, listen to each other's opinions, and work successfully. This method promotes trust, respect, and a better knowledge of one another's strengths and shortcomings.

Complementary skills and viewpoints: One of the benefits of beginning a business with your spouse is the ability to capitalize on each other's distinct talents and viewpoints. You may have unique skill sets, experiences, and areas of expertise that complement one another wonderfully. By combining your abilities, you may form a well-rounded team that is prepared to face a variety of business issues.

Greater Flexibility and Work-Life Balance: As company partners, you may design a work environment that fits your lifestyle and priorities as a pair. You may plan your work schedules, create limits, and prioritize family time in accordance with your beliefs and goals. This flexibility may result in a better work-life balance and a greater sense of fulfillment, both personally and professionally.

Building a Legacy Together: Starting a business with your spouse allows you to leave a lasting legacy that you will be proud of. Together, you are creating something significant that has the

potential to improve not just your own but also the lives of others, whether via job creation, creative goods or services, or community contributions.

Support and motivation: Entrepreneurship may be a difficult path with ups and downs. Having your spouse as a business partner gives you built-in support and inspiration during difficult times. You may celebrate wins together, encourage one another during failures, and offer unflinching support as you navigate the ups and downs of company ownership.

Finally, starting a business with your spouse may increase your emotional connection and bond as a couple. Working toward a common goal, conquering challenges, and celebrating accomplishments may all result in shared memories and experiences that improve your relationship and foster a sense of togetherness and collaboration,

Starting a business with your spouse provides a unique opportunity to blend your personal and professional lives in a meaningful and gratifying way. While it may present its own set of obstacles, the benefits, both personally and professionally, may be immense. By going on this adventure together, you have the opportunity to create a great business empire while also cultivating a strong and loving relationship that will withstand the test of time.

What Can You Expect from This Guide?

This book is a road map guide that will present you with practical insights, tactics, and concrete guidance to help you navigate your entrepreneurial path as a partnership. Whether you're just starting out or seeking to expand your current business, this book will help you overcome obstacles, capitalize on opportunities, and develop a successful business empire while maintaining a healthy and harmonious relationship with your spouse.

Here's what to expect from this guide:

Comprehensive Coverage: This guide covers every element of beginning and building a business with your partner, from setting the groundwork and preparing for success to managing roles and duties, overcoming obstacles, and scaling your firm for long-term success.

Practical Insights: You'll find useful advice, real-life examples, and concrete tactics to help you on your own entrepreneurial path. Whether you're developing a company strategy, managing money, or resolving workplace problems, this book will help you negotiate the difficulties of entrepreneurship as a couple.

Tailored Advice: We recognize that each marriage is unique, and there is no one-size-fits-all strategy to entrepreneurship. That is why

this book provides specialized guidance that you may modify to suit your own circumstances, goals, and problems.

Focus on Relationship Building: While the goal of this guide is to help you develop a successful business empire, we also realize the value of fostering a healthy, loving relationship with your spouse. You'll discover methods and tactics for successful communication, dispute resolution, and achieving a good work-life balance as a pair.

Inspiration and Motivation: Starting your own business might be difficult, but it is also extremely rewarding. Throughout this guide, you'll read about the experiences of couples who have successfully navigated the highs and lows of entrepreneurship together, giving you inspiration and drive to pursue your own entrepreneurial goals.

Resources and enhancement Reading: Furthermore, this guide provides a list of resources and recommended reading to deepen your understanding of key themes and enrich your entrepreneurial education.

This is the go-to resource for couples who want to begin on the thrilling path of entrepreneurship together. Whether you're just starting out or want to take your business to the next level, this book will help you every step of the way. So select your buddy, dig in, and let's begin creating your business empire together!

Chapter 1

Laying the Foundation

Laying the Foundation is an important step in the process of developing a business empire as a pair since it establishes the groundwork for your venture's success and longevity. This phase entails numerous crucial procedures and considerations that are critical for laying a solid foundation on which to grow your business together.

Establishing the foundation entails evaluating your interpersonal dynamics. Starting a business with your spouse necessitates a thorough awareness of one another's skills, limitations, communication styles, and working preferences. Take the time to have open and honest talks about your own business objectives, aspirations, and expectations, as well as how you see the team functioning together.

Identifying similar aims and values is another important part of setting the groundwork. As a pair, you must integrate your company objectives with your personal beliefs and long-term vision for the future. Discuss what success means to each of you, what values you want your company to represent, and how you want to make a good difference in your industry or community.

Establishing communication methods is critical for a healthy and effective working relationship between company partners. Effective communication is essential for resolving disagreements, making decisions, and coordinating your efforts toward common goals. Consider having frequent check-ins, allocating specific time for business talks, and creating clear routes for exchanging feedback and ideas.

Setting the groundwork entails establishing roles and duties inside the company. Clarifying who will be responsible for which responsibilities, areas of expertise, and decision-making power helps to reduce confusion and conflict in the future. Take the time to discuss each other's abilities and interests, and assign duties accordingly, so that you may successfully exploit each other's skills.

Creating the groundwork entails defining limits and achieving a good work-life balance. Starting a business together might be overwhelming, but it's critical to spend quality time together as a pair and keep your personal and work life separate. Setting clear limits for work hours, distinct workspaces, and disconnected time can help you avoid burnout and preserve harmony in your relationship.

Laying the groundwork is an important step in the process of creating a corporate empire as a pair. It entails examining your relationship dynamics, finding shared objectives and values,

developing communication methods, defining roles and duties, and creating limits in order to maintain a positive work-life balance. By spending time and effort in creating a solid foundation, you position yourself for success and assure the long-term viability of your company initiative.

Assessing Your Relationship Dynamics

Assessing your marital dynamics is an important step in developing a commercial empire as a pair. Before embarking on the entrepreneurial path together, it's critical to assess the dynamics of your relationship and ensure that you have a stable foundation to support your company ventures.

This evaluation requires you to reflect on several areas of your relationship, such as communication patterns, conflict resolution tactics, shared values, and overall compatibility as life and business partners. It's an opportunity to assess your skills, limitations, and areas for progress in order to better manage the obstacles of entrepreneurship as a pair.

Begin by assessing your communication techniques and habits. Effective communication is the foundation of any successful connection, but it's especially important in business partnerships. Consider how you and your spouse communicate with each other, both in regular situations and while discussing big issues or

problems. Can you express your thoughts and feelings openly and honestly? Do you actively and empathetically listen to one another's perspectives? Assessing your communication dynamics can help you find areas for improvement and develop good communication practices that will benefit your business cooperation.

Next, think about how you and your spouse manage arguments and disagreements. Conflict is unavoidable in each relationship; however, how you handle it defines the quality of your connection. Consider previous disputes and their settlements. Did you approach them with respect and empathy, or did the situation grow into disputes or resentment? Assessing your conflict resolution dynamics can help you find any reoccurring patterns or places where you may need to improve your techniques for constructive conflict resolution and relationship harmony.

In addition, consider your shared beliefs and aspirations as a pair. Building a corporate empire necessitates alignment not just with your commercial objectives, but also with your personal beliefs and goals. Consider your personal and common objectives, aspirations, and values, and examine how these relate to your corporate vision. Are you both devoted to the same long-term goals? Do you have comparable beliefs and concepts that will drive your decisions as business partners? Assessing your shared values and goals can help

you stay on track and strive toward a common vision for your company empire.

Think about your general compatibility as partners in life and business. Consider your unique talents and shortcomings, as well as how they can complement one other in a business relationship. Evaluate your abilities to encourage and uplift one another, both professionally and personally. Are you able to collaborate successfully as a team, harnessing one another's talents to overcome obstacles and achieve success? Assessing your compatibility as partners can help you uncover areas where you can improve synergy and collaboration, eventually enhancing your relationship as you begin on the adventure of establishing a corporate empire together.

Examining your relationship dynamics is an important stage in the process of creating a commercial empire as a pair. Reflect on your communication patterns, conflict resolution tactics, shared values, and general compatibility as life and business partners. Taking the time to assess these dynamics allows you to find strengths, shortcomings, and places for development, ensuring that you have a firm basis for your entrepreneurial journey together.

Identifying Shared Goals and Values

Identifying similar aims and values is an important stage in the process of creating a business empire as a partnership. It entails diving deeply into your dreams, desires, and basic values in order to create a shared vision that will guide your entrepreneurial pursuits and enhance your partnership.

Begin by having open and honest talks with your spouse about your own objectives and desires. Share your future goals, both personal and professional, and urge your spouse to do the same. Discuss your professional objectives, financial goals, lifestyle preferences, and any other goals that are significant to you. By freely revealing your personal objectives, you may uncover areas of overlap and alignment, building the foundations for creating common goals that will serve as the cornerstone of your company empire.

Talk about your shared values as a pair. Reflect on the principles, beliefs, and ethics that are important to both of you, and let them guide your decision-making. Discuss issues including integrity, honesty, social responsibility, and work-life balance, as well as the values you prioritize in both your personal and professional lives. Identifying shared values guarantees that your company empire is founded on a sound ethical basis that is consistent with your underlying convictions as a partnership.

Once you've defined your individual goals and common values, collaborate to set broad objectives for your company empire. These objectives should reflect your whole vision for the future, including both your career aims and personal beliefs. Discuss where you see your company empire in five, ten, or twenty years, and establish clear, measurable, attainable, relevant, and time-bound (SMART) objectives to guide your efforts and track your success along the way.

In addition to creating broad goals, create particular targets and milestones to assist you reach your long-term vision. Break down your goals into smaller, more concrete tasks that you can accomplish on a daily, weekly, or monthly basis. Setting defined targets and milestones allows you to measure your progress, keep focused on your priorities, and celebrate your successes as you collaborate to develop your company empire.

Examine and assess your shared objectives and values on a regular basis to ensure they remain relevant to your changing priorities and aspirations. As you negotiate the obstacles and possibilities of entrepreneurship together, your objectives and values may change, forcing you to review and realign your vision for the future. Maintaining open communication and revisiting your shared objectives and beliefs on a frequent basis will guarantee that your

company empire continues to represent your couple's combined vision and ideals.

Having common goals and values is an essential stage in the process of creating a corporate empire as a pair. By freely discussing your individual ambitions, investigating your shared values, and defining overall goals for your company empire, you can develop a shared vision that will lead your entrepreneurial pursuits and enhance your relationship. You can keep your company empire aligned with your joint objectives and beliefs while you work together to achieve success by maintaining open communication and doing frequent reviews.

Establishing Communication Strategies

Couples who want to establish a business together must develop excellent communication skills. Strong communication creates the groundwork for a successful partnership, promotes trust and understanding, and allows couples to negotiate obstacles and make educated decisions as they pursue their business objectives.

Prioritize open and honest conversation in your relationship. Create a secure and supportive atmosphere in which you may freely communicate your views, feelings, and concerns. Encourage active listening, empathy, and respect for one another's opinions. By encouraging open communication, you may establish trust and improve your bond as you tackle the intricacies of business together.

Set up regular communication procedures to keep each other informed and aligned. Set aside specific time for business conversations, such as a weekly check-in meeting or daily debriefings. Use this opportunity to reflect on progress, address obstacles, and make joint choices. Consistent communication helps to avoid misunderstandings, ensure that all partners are on the same page, and foster a sense of shared ownership in the organization.

In addition to scheduled meetings, use informal contact methods to remain in touch throughout the day. Use technology such as messaging applications, email, or phone calls to communicate

information, ask questions, and provide assistance as required. Staying connected and responsive allows you to solve issues quickly, maintain momentum, and cultivate a culture of cooperation and teamwork in your firm.

Communicate clearly and transparently when addressing crucial decisions or sensitive issues. Open up about your plans, preferences, and worries, and urge your spouse to do the same. Clarify your expectations, limits, and goals to guarantee mutual understanding and alignment. By being transparent, you may reduce misconceptions, create trust, and make educated decisions that benefit both the business and your relationship.

Create ways for addressing disputes and disagreements productively. Conflict is unavoidable in each connection, but how you manage and overcome it affects the quality of your relationship. Approach disagreements with a collaborative perspective, concentrating on finding solutions that satisfy both partners' needs. Active listening, empathy, and compromise may help you achieve mutually good solutions while also strengthening your connection.

Prioritize constant communication and feedback in order to promote continuous progress and growth. Regularly seek input from your spouse on your communication style, teamwork, and partnership dynamics. Be receptive to constructive feedback and commit to addressing areas for improvement together. By constantly

improving your communication tactics, you may deepen your alliance, increase your efficacy as business partners, and achieve more success as you develop your empire together.

Couples who want to start a business together must develop efficient communication skills. Couples can lay a solid foundation for their relationship and navigate the challenges of entrepreneurship with clarity, collaboration, and mutual support by prioritizing open and honest communication, establishing regular communication routines, practicing transparency, managing conflicts constructively, and prioritizing ongoing feedback.

Chapter 2

Finding Your Niche

Finding your expertise is an important stage in the process of creating a successful business empire as a partnership. It entails finding a specialized market segment or target population that shares your interests, experience, and company objectives. Finding your niche allows you to separate your firm from rivals, develop a devoted client base, and position yourself for long-term market success.

Begin by completing an extensive study to uncover prospective niches that are compatible with your hobbies, passions, and areas of skill. Consider your professional histories, interests, abilities, and areas of expertise that you may use to provide value to your target audience. Investigate various sectors, markets, and client groups to uncover areas where you may offer a distinctive contribution, address unmet requirements, or solve critical issues.

Next, examine market demand and competition in your selected niche. Conduct market research to determine the size of your target market, consumer demographics, purchasing habits, and

competitive environment. Analyze current competition to uncover gaps or untapped areas where you may differentiate your company and provide distinct value propositions to your target customer, then evaluate your unique value proposition and how you may distinguish your company within your selected area.

Identify what distinguishes you from competitors and why customers should prefer your products or services over others. Consider how quality, pricing, customer service, branding, and innovation may help you stand out in the industry and attract customers to your company. Additionally, evaluate the profitability and scalability of your selected specialty. Determine the possibilities for revenue generation, profit margins, and growth prospects in your specialized market. Consider the market size, demand patterns, price dynamics, and entry obstacles that may affect your company's profitability and long-term survival.

However, evaluate your personal and professional goals, as well as how your selected expertise fits into them. Consider your long-term ambitions for your company empire, such as financial targets, lifestyle choices, and impact objectives. Choose a specialty that not only reflects your hobbies and expertise but also supports your overall goals and vision for the future. Finally, be adaptable and willing to refine your specialization over time, depending on feedback and market trends. Monitor industry trends, consumer

input, and competition developments to be flexible and responsive to changing market conditions. Continuously analyze and change your niche approach to ensure that it stays relevant, competitive, and aligned with your business goals and objectives as you work together to create your empire.

Identifying your expertise is an important stage in the process of creating a company empire as a pair. By focusing on a specialized market sector that matches your interests, experience, and business objectives, you can differentiate your company, build a devoted client base, and position yourself for long-term success in the marketplace. Through careful research, market analysis, differentiation techniques, and alignment with your goals, you can locate the ideal niche for your company empire and set yourself up for success as you begin on this entrepreneurial journey together.

Brainstorming Business Ideas

Brainstorming company ideas is an exciting and necessary part of the process of creating a successful business empire as a pair. It entails developing unique and new concepts that are consistent with your interests, abilities, and goals while also addressing market demands and possibilities.

Here's a complete and comprehensive method for brainstorming company ideas:

1. Identify your passions and interests: Begin by identifying your individual and couple passions, hobbies, and interests. Consider activities you love, topics you are knowledgeable about, and causes that ignite your passion. Brainstorming company ideas based on your passions boosts your drive and pleasure for the entrepreneurial path.

2. Use Your Skills and Expertise: Consider your professional experience, talents, and areas of specialization. Identify your individual and couple strengths and areas of success. Consider how you can use your talents and knowledge to provide value to clients and differentiate your company in the marketplace.

3. Consider market needs and opportunities: Investigate market trends, customer behavior, and potential prospects in your business or niche market. Identify unmet requirements, pain spots, and

market gaps that your company concept can fill. Look for new ways to innovate, enhance existing goods or services, or provide innovative solutions to client issues.

4. Explore Collaboration Opportunities: Create company ideas based on the strengths and dynamics of your couple's relationship. Consider how you may leverage your abilities, interests, and resources to gain a competitive advantage in your business initiatives. Investigate collaborative business models, joint ventures, or partnerships that use your complimentary talents and skills.

5. Consider long-term sustainability: Consider the long-term viability and scalability of your company's concepts. Evaluate market demand, growth potential, and competitive dynamics to determine the long-term feasibility of your company's plans. Look for ways to create a sustainable company strategy that can adapt to changing market conditions and expand alongside your business empire.

6. Be creative and think beyond the box: Encourage originality and unconventional ideas throughout the brainstorming session. Investigate unorthodox ideas, unique solutions, and disruptive business models that have the ability to distinguish your company and attract market attention. Encourage experimentation and exploration as you develop and enhance company concepts.

7. Seek Inspiration: To inspire fresh ideas and possibilities, look to successful entrepreneurs, industry trends, and upcoming technology. Attend industry events, conferences, and networking opportunities to meet other entrepreneurs and learn about current business trends and prospects. Find inspiration from a variety of sources, including books, podcasts, and internet resources, to feed your creativity and invention.

8. Evaluate and prioritize ideas: After brainstorming a variety of company ideas, assess and rank them based on market need, practicality, compatibility with your goals and beliefs, and long-term viability. Consider performing feasibility studies, market research, or prototype testing to confirm your ideas and pinpoint the most potential chances for your company's empire.

9. Refine and iterate: Refine and iterate your company concepts based on comments, insights, and market research. Seek feedback from mentors, advisers, or future customers to obtain new views and pinpoint areas for growth. Iterate on your ideas on a regular basis, polishing them to better satisfy client demands, address market possibilities, and connect with your long-term corporate goal.

10. Choose Your Best Idea: Finally, select the company concept that most closely matches your hobbies, abilities, market potential, and long-term ambitions. Choose the concept that connects most deeply with you as a couple and has the most chance of success in

the marketplace. Trust your intuition and commit to pursuing your selected concept with enthusiasm, devotion, and tenacity as you begin on the path to create your company empire together.

Brainstorming company ideas is an important and exciting phase in the process of creating a business empire as a pair. You and your partner may produce new and original company concepts that have the potential to succeed in the marketplace by combining your interests, talents, market knowledge, and collaboration dynamics. Through creativity, cooperation, and strategic thinking, you may find and develop the company concept that best matches your vision for your empire and puts you on the path to entrepreneurial success.

Researching Market Opportunities

Researching market potential is an important stage in establishing a company's empire as a pair. It entails acquiring information on industry trends, client wants, competitive dynamics, and upcoming prospects in your selected market.

Here's a thorough technique for investigating market opportunities:

Begin by completing industry research to acquire a thorough grasp of the market landscape and dynamics in your specific sector or specialty. Explore industry research, market studies, and trade publications to learn about market size, growth trends, key players, and competitive dynamics. Identify new trends, technical breakthroughs, and regulatory changes that might affect the industry and generate possibilities for your company.

Next, do consumer research to better understand your target audience's requirements, preferences, and habits. Conduct surveys, interviews, or focus groups with potential consumers to gain firsthand knowledge about their pain areas, desires, and purchase patterns. Create rich client personas using demographic data, psychographic profiles, and purchasing motives to drive your marketing and product development activities.

Conduct competition research to better grasp the strengths, weaknesses, and plans of current rivals in your industry. Identify and assess direct and indirect rivals' products or services, pricing methods, distribution routes, and marketing techniques. Assess their strengths and limitations in comparison to your own business plan, and look for ways to differentiate your company and achieve a competitive edge in the industry.

Investigate market segmentation to uncover specific client categories or niche markets that may offer opportunities for your company. Analyze demographic, regional, behavioral, and psychographic elements to divide the market into discrete groups with their own requirements and preferences. Identify underdeveloped or ignored niches where your company may add value and acquire a presence in the market.

Evaluate the competitive environment and entry hurdles in your target market. Consider issues such as market saturation, competition intensity, and entrance hurdles like regulatory restrictions, capital expenditure, or technological competence. Identify gaps or underdeveloped regions where your company may establish a niche and acquire a competitive edge. Consider doing a SWOT (Strengths, Weaknesses, Opportunities, Threats) study to evaluate your company's internal strengths and weaknesses, as well as market-wide opportunities and threats. Identify possibilities to

harness your strengths and manage your weaknesses while simultaneously dealing with possible risks and seizing on new market opportunities.

Combine your study findings to identify important market possibilities that are consistent with your company's concept, goals, and strengths as a pair. Prioritize prospects based on market demand, growth potential, competitive dynamics, and alignment with your long-term business goal. Choose the most promising prospects that match your couple's talents and objectives, which will serve as the foundation for your entrepreneurial ventures.

Investigating market prospects is an important phase in the process of creating a company empire as a pair. By researching industry trends, consumer demands, competitive dynamics, and new possibilities in your target market, you may uncover important opportunities that connect with your company's concept, goals, and strengths as a partnership. Through extensive study and analysis, you may position your company for market success and establish the groundwork for a profitable corporate empire.

Narrowing Down Your Niche

Narrowing down your specialization is an important stage in establishing a company empire as a pair. It entails narrowing your focus and determining a precise market segment or target audience that most closely matches your interests, abilities, and company objectives. Narrowing your specialization allows you to better position your firm, separate yourself from competition, and develop a devoted consumer base.

Begin by analyzing the ideas and conclusions from your preliminary market research and brainstorming sessions. Consider the numerous company concepts and market prospects you've investigated and choose which ones connect most strongly with you as a pair. Consider your hobbies, interests, and areas of skill, as well as the potential for development and profit in each niche.

Next, evaluate the market demand and competition for each prospective niche. Consider the target market's size, demographics, purchasing behavior, and competitive environment. Assess the extent of competition, entry obstacles, and opportunities for differentiation and innovation in each niche.

Consider the long-term viability and scalability of each conceivable niche. Consider market trends, development potential, and the availability of resources and infrastructure to help your firm grow

and expand within each specialty. Examine whether each specialization is consistent with your long-term objectives and aspirations as a marriage and has the ability to support the expansion of your company's empire over time.

Once you've narrowed down your niche, concentrate your efforts on gaining a thorough understanding of your target audience, improving your products or services, and implementing a specific marketing and sales plan to attract clients and expand your firm within that niche. By limiting your specialization and focusing your efforts on a certain market sector, you may better position your company, distinguish yourself from competition, and develop a successful commercial empire as a pair.

Narrowing your niche allows you to streamline your operations and concentrate your efforts on the areas that generate the most value for your company. By focusing on a specific market segment, you can improve your processes, resources, and workflows to better meet the needs of your target audience. This focus enables you to provide higher-quality products or services, increase customer satisfaction, and establish a strong reputation for excellence in your niche, resulting in long-term success for your business empire.

Narrowing your niche is an important step in the process of creating a business empire as a couple. By focusing your efforts on a specific market segment that matches your interests, skills, and business

objectives, you can better position your company, differentiate yourself from competitors, and attract a loyal customer base. This targeted approach allows you to better allocate your resources, establish yourself as an authority in your niche, create a more effective marketing strategy, and streamline your operations to ensure long-term success. With careful consideration and strategic decision-making, you can narrow your niche and lay the groundwork for a thriving business empire as a couple.

Chapter 3

Planning for Success

Planning for success is essential for couples starting a business empire together. To achieve success in your entrepreneurial endeavors, you must first establish clear goals, create a strategic roadmap, and implement effective strategies.

Here is a detailed and comprehensive approach to success planning:

1. Define Your Vision and Goals: Begin by defining your shared vision for your business empire and establishing specific, measurable, achievable, relevant, and time-bound (SMART) goals to guide your efforts. Take into account your long-term goals, financial objectives, and desired impact, both personally and professionally. Define what success looks like for you as a couple, as well as the milestones and goals you need to achieve.

2. Conduct a SWOT Analysis: Assess your company's strengths, weaknesses, opportunities, and threats (SWOT) to identify internal strengths and weaknesses, as well as external market opportunities and threats. Utilize this analysis to identify areas of competitive advantage, potential risks, and opportunities for improvement. To position your company for success, leverage your strengths,

minimize your weaknesses, capitalize on opportunities, and mitigate threats.

3. Create a Strategic Plan: Using your vision, goals, and SWOT analysis, create a strategic plan outlining your approach to achieving success in your business empire. Define your target market, value proposition, competitive positioning, and key growth and profit strategies. Product development, marketing and sales, operations, finance, and human resources should all be considered when developing a comprehensive strategy for success.

4. Allocate Resources Wisely: Determine the resources required to effectively implement your strategic plan, such as financial resources, human capital, technology, and infrastructure. Allocate resources wisely to ensure that you have the tools, talent, and capabilities to put your strategies into action and achieve your objectives. Budgeting, resource allocation, and risk management are all important factors to consider when maximizing your resource allocation and chances of success.

5. Implement Effective Strategies: Put your strategic plan into action by implementing effective strategies in all aspects of your company's operations. Create a marketing and sales strategy for attracting customers and increasing revenue. Implement operational processes and systems to streamline workflows and boost efficiency. Develop a strong team of employees, partners, and

advisors to help your company grow and succeed. Monitor your progress, track key performance indicators (KPIs), and adjust as needed to stay on track to meet your objectives.

6. Promote Collaboration and Innovation: Create a collaborative, creative, and innovative culture within your business empire. Encourage employees and partners to communicate openly, work together, and share their knowledge. Encourage the creation of an environment that fosters new ideas and experimentation. Develop a growth mindset and embrace continuous learning and improvement to stay ahead of the competition and drive industry innovation.

7. Monitor and Adapt: Check in on your progress toward your goals on a regular basis and make adjustments as needed to stay on track. Track key performance indicators (KPIs) and metrics to assess the efficacy of your strategies and tactics. Be proactive in identifying opportunities for improvement and dealing with any challenges or obstacles that arise along the way. Stay agile and adaptable, and be willing to pivot your strategies and tactics as needed to navigate changing market dynamics and emerging opportunities.

8. Celebrate Achievements and Learn from Failures: Celebrate your achievements and milestones as you progress towards building your business empire together. Recognize and reward the hard work and dedication of your team and partners. Celebrate successes, big and small, and use them as motivation to continue pushing forward

towards your goals. Additionally, embrace failures as learning opportunities and use them to glean valuable insights and lessons that can inform future decision-making and improve your chances of success.

9. Maintain Work-Life Balance: Prioritize maintaining a healthy work-life balance as you build your business empire together. Make time for relaxation, self-care, and quality time with your partner and loved ones outside of work. Set boundaries around work hours and commitments to prevent burnout and maintain your physical, mental, and emotional well-being. Remember that success is not just about achieving your business goals but also about living a fulfilling and balanced life as a couple.

Planning for success is a comprehensive and ongoing process that involves defining your vision and goals, conducting a SWOT analysis, developing a strategic plan, allocating resources wisely, implementing effective strategies, fostering a culture of collaboration and innovation, monitoring progress and adapting, celebrating achievements, and maintaining work-life balance. By following this comprehensive approach, you can lay the foundation for a successful business empire as a couple and achieve your shared vision of success and fulfillment in entrepreneurship.

Crafting a Business Plan Together

Making a company plan jointly is an important stage in the process of establishing a business empire as a pair. A business plan contains your company's goals, strategy, operations, and financial predictions. It offers a thorough framework for directing your company's growth and success, as well as a useful tool for attracting investors, acquiring finance, and coordinating your activities as a partnership.

Here's a full and complete technique for creating a business strategy collaboratively:

1. Define Your Vision and Mission: Begin by establishing a common vision and objective for your business empire. Your vision should express your long-term ambitions and goals, whereas your mission should define the purpose and values that drive your company. Discuss your values, beliefs, and goals as a pair, and determine how your business can help you achieve them.

2. Conduct market research: Conduct extensive market research to gain knowledge about your industry, target market, and competitive landscape. Analyze market trends, consumer demographics, purchasing behavior, and rival strategies to uncover opportunities and difficulties in your industry. Use this information to help you develop your business strategy and positioning.

3. Develop a Value Proposition: Define your unique value proposition that distinguishes your company from rivals and appeals to your target audience. Determine the primary benefits and advantages of your products or services, and explain how they meet specific client demands or problem areas. Your value proposition should clearly describe the value you provide to consumers and why they should select you over competitors.

4. Outline your products or services: Describe in detail the items or services you want to provide in your firm. Define each offering's features, advantages, and pricing, as well as how they address the demands of your target market. Consider product creation, sourcing, production, and distribution when outlining your product or service offering.

5. Identify Your Target Market: Define your target market by specifying the client categories or demographics you intend to reach. Describe your ideal consumer profile, including demographics, psychographics, and buying habits. Identify your target market's wants, preferences, and pain spots, then describe how your company will meet them.

6. Create a marketing strategy: Develop a marketing plan for gaining and maintaining consumers. Describe your branding, positioning, and message initiatives, as well as the marketing channels and approaches you intend to employ to reach your desired

audience. Consider digital marketing, social media, content marketing, advertising, and other promotional activities while developing your marketing plan.

7. Prepare an Operations Plan: Create an operational strategy outlining how your firm will run on a daily basis. Describe your business processes, workflows, and systems, as well as the resources and infrastructure required to run your operations. Consider production, inventory management, customer service, and logistics while developing an operations strategy.

8. Outline your management team: Describe the important members of your management team, including their positions, duties, and credentials. Highlight your combined abilities, experience, and knowledge as a pair, as well as any advisers, mentors, or partners who will help you with your business. Explain how your team's talents will contribute to the success of your company's empire.

9. Develop a Financial Plan: Create a thorough financial plan including your company's income, costs, and cash flow estimates. Include a starting budget outlining your initial investment requirements as well as a financial prognosis projecting your company's financial success over the following three to five years. Consider sales predictions, pricing strategy, cost of products sold,

operational expenditures, and finance requirements while creating your financial plan.

10. Set Goals and Milestones: Set clear, measurable, attainable, relevant, and time-bound (SMART) objectives and milestones for your company. Set both short-term and long-term goals that are consistent with your vision and mission, and identify the significant milestones you must meet along the way. Set goals and milestones to track your development and assess the success of your company's empire.

11. Review and revise: After you've completed your business strategy, examine it as a pair and get comments from trustworthy advisers, mentors, or business partners. Revise your company plan as required to integrate comments and ensure that it correctly represents your common vision, goals, and tactics. Consider changing your business plan on a frequent basis as your firm grows and conditions change.

Creating a business plan is a collaborative and iterative process that includes defining your vision and mission, conducting market research, developing a value proposition, outlining your products or services, identifying your target market, developing a marketing strategy, developing an operations plan, outlining your management team, developing a financial plan, setting goals and milestones, and reviewing and revising your plan as needed.

Working as a team to construct a detailed business plan allows you to synchronize your efforts, set clear goals, and position your firm for success as you expand your empire together.

Setting SMART Goals

Setting SMART objectives is critical for couples building a business empire together. SMART is an abbreviation that stands for Specific, Measurable, Achievable, Relevant, and Timely. Setting SMART goals allows couples to define clear, concrete objectives that direct their efforts and drive progress toward their common vision.

Here's a full and comprehensive technique for creating SMART goals:

1. Specific: Begin by creating explicit goals that clearly express what you intend to achieve. Avoid unclear or confusing objectives in favor of specific and clearly stated goals. Instead of declaring a goal to "increase sales," state the amount or percentage by which you want to grow sales within a certain time frame.

2. Measurable: Make sure your objectives are quantifiable so you can monitor your progress and assess your success. Determine the metrics, or key performance indicators (KPIs), you will use to track progress toward your objectives. This might contain indicators like

revenue, profit margin, customer acquisition, conversion rate, and any other data that is important to your business goals.

3. Achievable: Set objectives that are attainable and reasonable given your resources, talents, and circumstances. When defining objectives, take into account your budget, time limits, talents, and available resources. While it is necessary to create ambitious objectives that challenge your talents, avoid setting goals that are too ambitious or impractical to fulfill within your limits.

4. Related: Make sure your goals are relevant and consistent with your overarching vision, purpose, and strategic priorities as a pair. Consider how each objective fits into your long-term goals and the success of your company's empire. Align your goals with your beliefs, interests, and areas of competence, and prioritize those that have the most influence on attaining your common vision.

5. Time bound: Set explicit deadlines or timetables for completing your objectives to instill a feeling of urgency and accountability. Define specific start and finish dates for each objective, and divide bigger goals into smaller, more achievable milestones with deadlines. This helps you build momentum and drive as you try to meet your goals within the timeframe given.

In addition to adhering to the SMART criteria, couples should consider the following guidelines while making goals: Collaborate

and communicate openly. As a pair, define objectives together and guarantee congruence between your individual aims and joint vision. Communicate clearly about your interests, worries, and expectations to ensure that your goals take into account both partners' viewpoints.

Prioritize and focus: identify the most important goals for your company's success and prioritize them accordingly. Concentrate on a few major goals at a time to avoid spreading yourself out and diluting your efforts.

Break down larger goals: Divide larger, longer-term objectives into smaller, more attainable milestones or activities. This makes objectives more reachable and helps you better track progress, giving you a sense of success as you reach each milestone.

Review and adjust: Review your objectives on a regular basis, analyze your progress, and make adjustments to your plans as needed in response to changing circumstances or new insights. Be adaptable and willing to adjust your goals to meet shifting priorities or unanticipated problems.

Celebrate your accomplishments and milestones along the way to stay motivated and on track. Recognize your couple's accomplishments and use them as motivation to keep working toward your common goal of building a successful business empire.

Adopting SMART objectives is critical for couples launching a business empire together. Couples may use the SMART criteria and other recommendations for effective goal planning to develop clear, concrete objectives that direct their efforts and drive progress toward their shared vision. With well-defined goals, couples can synchronize their efforts, stay focused, and succeed as they grow their economic empire together.

Creating a Shared Vision

Developing a common vision is a critical first step for couples launching a business empire together. A shared vision acts as a guiding light, aligning both partners' objectives, beliefs, and goals while offering clarity and direction for the path ahead.

Here's a detailed and complete strategy for developing a common vision:

1. Open and honest communication: Begin by promoting open and honest conversation in your relationship. Take the time to explore your own aims, values, and future goals. Share your aspirations, passions, and desires with your spouse, and urge them to do the same. Actively listen to each other's points of view and try to understand their motives and objectives.

2. Identify shared values and interests: Investigate areas of shared beliefs, interests, and aspirations as a pair. Determine which values, beliefs, and ideals are essential to both couples. Consider common interests or passions that you may use to your advantage in your business ventures. This might be common hobbies, causes, or professional interests that you both care deeply about.

3. Imagine Your Ideal Future: Consider your ideal future as a couple. Imagine the type of life you want to have for yourself, both personally and professionally. Consider your lifestyle, family life, professional ambitions, financial objectives, and legacy. Visualize the influence you want to have on the world and the legacy you want to leave behind with your company empire.

4. Define Your Shared Purpose: Clarify your company's goals and objectives as a pair. Define the underlying goal or "why" behind your business pursuits, as well as the impact you hope to have on the world. Consider how your company will add value to people, solve issues, or have a good influence on your community or industry.

5. Develop Long-Term Goals and Aspirations: Establish long-term objectives and aspirations that represent your common vision for the future. Discuss your goals as a pair in five, 10, or twenty years. Consider your financial security, personal development, family life, and the expansion and success of your company empire. Set lofty

but feasible goals that will excite and push you both to strive toward a common destiny.

6. Create a Vision Statement: Reduce your shared vision to a clear and succinct vision statement that captures your couple's objectives and aims. Create a powerful statement that expresses your common mission, values, and long-term goals for your company empire. Your vision statement should inspire and encourage both partners while also serving as a guiding beacon for your collaborative entrepreneurial journey.

7. Revisit and refine regularly. Regularly examine and fine-tune your joint vision as a pair. As you go through your business path, circumstances may alter, presenting new chances or problems. Take the time to examine your couple's vision, goals, and priorities, and make any necessary modifications to keep on track with your changing aspirations. Continue to reconfirm your devotion to each other and your common goal for your company empire.

8. Visualize Your Future Together: Visualize your future together as a pair and become immersed in the joint vision you've created. Use visualization tools to visualize reaching your goals and realizing your common ambitions. Visualize the success of your corporate empire, the achievement of your personal goals, and the effect you wish to have on the world. Embrace the power of imagination to bring your common vision to life.

Developing a shared vision is a collaborative and transformational process that unites couples' aspirations, beliefs, and goals as they build a business empire together. Couples can create a compelling shared vision that guides and inspires them on their entrepreneurial journey by encouraging open communication, identifying common values and interests, envisioning your ideal future, defining your shared purpose, setting long-term goals, crafting a vision statement, revisiting and refining it on a regular basis, and visualizing your future together. Couples that have a common vision may handle the obstacles and possibilities of developing a business empire with clarity, purpose, and harmony.

Chapter 4

Legal and Financial Considerations

Legal and financial issues are critical for couples building a company empire together. These considerations include a wide variety of issues, including the legal framework, contracts, taxes, funding, and more.

Here's a full and complete summary of the legal and economic considerations:

Legal framework: One of the first considerations couples must make is the legal framework of their firm. Sole proprietorship, partnership, limited liability company (LLC), and corporation are examples of common business structures. Each organization has unique consequences for liability, taxes, and administration; therefore, it's critical to select the form that best fits your objectives and circumstances.

Business licenses and permissions: Depending on the type of business and its location, you may be required to get many licenses and permissions in order to operate lawfully. Before starting your firm, research the unique regulations in your sector and area, and make sure you have all of the essential licenses and permissions.

Consider protecting your intellectual property, such as trademarks, copyrights, and patents, to defend your company's unique assets and ideas. Consult a legal professional to assess the best intellectual property protection tactics for your firm, and then register and enforce your rights as needed.

Contracts and Agreements: Creating clear and thorough contracts and agreements is critical for safeguarding your interests and managing relationships with customers, suppliers, workers, and others. Consider drafting contracts for services, employment agreements, non-disclosure agreements (NDAs), partnership agreements, and other applicable papers to outline rights, obligations, and expectations.

Taxation: Understand the tax consequences of your company's structure and operations, such as income taxes, self-employment taxes, and sales taxes. Consult a tax adviser or accountant to verify that you are in compliance with tax rules and regulations, as well as to find possibilities to reduce your tax liability through deductions, credits, and other measures.

Insurance: Consider the value of insurance coverage in protecting your business and personal assets from potential risks and obligations. Insurance options to consider include general liability insurance, property insurance, professional liability insurance, workers' compensation insurance, and others. Evaluate your

insurance requirements carefully and select plans that adequately cover your company's unique risks and exposures.

Financial Management: Implement strong financial management procedures to maintain the financial health and stability of your business empire. Create a complete budget, routinely monitor cash flow, and keep proper financial records. Implement internal controls and systems to protect assets and prevent fraud or mismanagement of finances. Consider collaborating with a financial counselor or accountant to improve your financial management procedures and increase profits.

Financing: Determine how you will fund your company empire, including launch expenditures, operational expenses, and expansion plans. Examine several financial alternatives, including personal savings, loans, lines of credit, investors, crowdsourcing, and grants. Consider the benefits and drawbacks of each option and select the best financing approach depending on your financial status, risk tolerance, and development goals.

Consider succession planning: As a long-term strategy for your company's empire. Create a strategy for transferring ownership and control of the company in the case of retirement, incapacity, or other unexpected circumstances. Consider family relationships, leadership development, and estate preparation to guarantee a seamless succession and continued operations.

Compliance and Regulations: Stay up-to-date on the rules, regulations, and industry standards that affect your company's operations. Maintain compliance with legal obligations in employment, taxation, environmental legislation, data protection, and other areas. Monitor regulatory changes and alter your company's processes properly to reduce risks and maintain long-term compliance.

Legal and financial issues are critical components of creating a company empire as a couple. Couples may safeguard their rights, assure legal compliance, and lay the groundwork for long-term entrepreneurial success by addressing these issues completely and proactively. Consultation with legal and financial specialists is critical for effectively navigating complicated legal and financial issues and making educated decisions that support the growth and sustainability of your business empire.

Choosing the Right Business Structure

Choosing the correct business structure is crucial for couples who want to build a business empire together. The business structure you select will have a substantial impact on liability, taxes, management, and other areas of your business operations.

Here's a complete and comprehensive summary of the things to consider while selecting the appropriate business structure:

1. Legal Liability: One of the most important factors when selecting a business structure is the amount of legal liability protection it provides. Corporations and limited liability companies (LLCs) provide limited liability protection, safeguarding the owners' personal assets from corporate debts and obligations. Other arrangements, such as sole proprietorships and general partnerships, do not provide this degree of protection, leaving owners personally liable for corporate debts and responsibilities.

2. Tax implications: Tax consequences for owners vary depending on the kind of business structure. Sole proprietorships and partnerships record income and losses on the owners' personal tax returns, as they are pass-through businesses. On the other hand, corporations are subject to independent taxation, potentially resulting in double taxation of earnings. Owners of LLCs can choose

whether to be taxed as a pass-through or as a distinct business, providing tax flexibility.

3. Management style: Think about which management style best suits your interests and goals as a pair. Some business arrangements, such as sole proprietorships and partnerships, provide greater freedom in management and decision-making since owners have complete authority over the company. Other institutions, such as companies, have a more organized management structure in which shareholders, directors, and officers make decisions.

4. Ownership and Control: Determine how you intend to arrange the business's ownership and control. Some company forms, such as partnerships and limited liability companies, allow partners or members to share ownership and decision-making power. Companies, on the other hand, allow for the issuance of stock shares, which shareholders can sell or transfer to raise funds or change ownership.

5. Flexibility and Complexity: Evaluate the degree of flexibility and complexity associated with each company structure. Sole proprietorships and partnerships are comparatively straightforward to establish and run, with fewer formalities and legal requirements. Corporations and LLCs, on the other hand, are more sophisticated and must adhere to formalities such as annual meetings, filings, and record-keeping.6. Cost and Administrative Needs: Determine the

cost and administrative needs for each business structure. Sole proprietorships and partnerships often have cheaper initial costs and fewer administrative obligations than corporations and limited liability companies, which may need registration fees, yearly filings, and other ongoing expenses.

7. Long-term goals: When deciding on a business structure, keep your long-term goals and desires in mind. Some structures may be better suited for scalability and expansion than others for lifestyle enterprises or smaller operations. Evaluate how each structure fits with your couple's development ambitions, exit strategies, and succession planning.

Selecting the appropriate business structure is an important step for couples embarking on a business venture together. Couples can make an informed decision for their entrepreneurial journey by carefully considering factors such as legal liability, tax implications, management structure, ownership and control, flexibility and complexity, cost and administrative requirements, and long-term goals. Consulting with legal and financial specialists may provide invaluable advice and assistance in determining the best company structure for your empire.

Understanding Tax Implications

Understanding the tax implications is critical for couples starting a business together. Taxes have a significant impact on a business's financial health and success, so it's critical for couples to understand how various tax considerations can affect their business operations, profitability, and personal finances.

Here's a detailed and comprehensive summary of the key tax implications to consider:

1. Business Structure: Couples starting a business empire must carefully consider the tax implications of their business structure. Different business structures, such as sole proprietorships, partnerships, corporations, and limited liability companies (LLCs), have different tax implications for their owners. Owners report the profits and losses of sole proprietorships and partnerships on their personal tax returns because these business structures are pass-through entities. On the other hand, corporations are taxed independently from their owners, potentially leading to double taxation of earnings.

2. Income Taxes: Income taxes are a major concern for couples launching a business empire. Owners of pass-through entities, such as sole proprietorships, partnerships, and limited liability companies, report business profits and losses on their individual tax

returns. Owners of pass-through entities, such as sole proprietorships, partnerships, and limited liability companies, pay taxes on business profits at their personal income tax rate. On the other hand, corporation owners may face double taxation because the corporate level taxes profits before distributing them to shareholders as dividends.

3. Self-employment Taxes: Couples who are self-employed or own a partnership or LLC may be subject to self-employment taxes, which include Social Security and Medicare contributions. Self-employment taxes are typically calculated using net earnings from self-employment, which include business income less allowable deductions. Understanding and budgeting for self-employment taxes is critical to managing cash flow and meeting tax obligations.

4. Employment tax: When couples hire employees for their business, they must comply with a variety of employment tax obligations, such as withholding federal income tax, Social Security, and Medicare taxes from employees' wages and making employer contributions to Social Security and Medicare taxes. Couples must also file payroll tax returns and pay withheld taxes to the appropriate tax authorities on a regular basis.

5. Sales tax: Depending on the nature of the business and its location, couples may be required to collect and remit sales taxes on products or services sold to customers. Sales tax requirements differ

by state and locality, so it's critical to understand the specific sales tax obligations that apply to the business and comply with all filing and remittance requirements.

6. Estimated Taxes: Couples who expect to pay a certain amount of tax on their business income may be required to make estimated tax payments throughout the year in order to avoid underpayment penalties. Couples typically make estimated tax payments quarterly, which include income tax, self-employment tax, and other business-related taxes.

7. Tax Deductions and Credits: Couples can use a variety of tax deductions and credits to reduce their tax liability and maximize their after-tax income. Couples can deduct common business expenses such as rent, utilities, supplies, equipment, marketing, and professional fees. Couples may also be eligible for tax credits, such as the Small Business Health Care Tax Credit or the Research and Development Tax Credit, depending on their business activities and situation.

8. Record-Keeping and Documentation: Proper record-keeping and documentation are required to ensure compliance with tax laws and regulations. Couples should keep accurate and organized records of business income, expenses, receipts, invoices, bank statements, and other financial documents. Good record-keeping practices not only

help with tax compliance, but they also provide useful documentation in the event of an audit or tax inquiry.

Couples who are starting a business together must understand the tax implications. Couples can effectively manage their tax obligations, optimize their tax situation, and comply with tax laws and regulations by taking into account factors such as business structure, income taxes, self-employment taxes, employment taxes, sales taxes, estimated taxes, tax deductions and credits, and record-keeping practices. Consulting with tax professionals or financial advisors can help you navigate the complexities of tax planning and compliance for your business empire.

Managing Finances as a Couple

Managing funds as a pair is an essential part of establishing a business empire together. Effective financial management creates the framework for financial stability, expansion, and success in both personal and professional undertakings.

Here's a full and comprehensive way to handle money as a couple:

1. Open Communication: Create an open and honest discussion regarding finances as a partnership. Discuss your financial objectives, beliefs, interests, and concerns freely and frequently. Create a secure, nonjudgmental atmosphere in which both partners may express their views and opinions on money.

2. Common Vision and Goals: Align your financial objectives and desires as a pair. Establish a shared vision for your future, both personally and professionally. Discuss your short- and long-term financial goals, such as retirement savings, property ownership, education finance, and company expansion. Make sure your objectives match both spouses' priorities and aspirations.

3. Budget: Make a detailed budget that includes your combined income, spending, and financial objectives as a pair. Track your spending, prioritize critical needs, and set aside money for savings, investments, debt reduction, and discretionary spending. To stay on

track with your financial objectives and adapt to changes in your financial condition, evaluate and update your budget on a regular basis.

4. Financial Planning: Create a thorough financial strategy that covers both your personal and corporate money. Consider the following: income, spending, assets, obligations, cash flow, taxes, insurance, investments, retirement planning, and estate planning. Set clear and achievable milestones to measure your progress and hold yourself accountable for meeting your financial objectives.

5. Debt Management: Evaluate and manage your debt as a pair. Identify and prioritize high-interest obligations for repayment, such as credit cards and personal loans. Create a debt payback strategy that works with your budget and financial goals. Consider combining or refinancing loans to reduce interest rates and simplify payments. Avoid incurring new debt, and exercise cautious borrowing practices.

6. Savings and Emergency Fund: Create a strong savings strategy as a pair to cover both expected and unforeseen costs. Create an emergency fund with three to six months' worth of living costs to meet unforeseen financial setbacks like job loss, medical bills, or business difficulties. Set aside more funds for specific financial objectives, such as a down payment on a home, raising a family, or expanding your company's empire.

7. Investment: Create an investing plan that is consistent with your risk tolerance, time horizon, and financial objectives as a pair. Consider the following investing options: equities, bonds, mutual funds, exchange-traded funds (ETFs), real estate, and retirement accounts. Diversify your investing portfolio to reduce risk and enhance rewards in the long run. Regularly examine and adjust your investment portfolio to ensure it is in line with your financial objectives and changing market circumstances.

8. Insurance: Insure your financial well-being as a partnership to manage risk effectively. Consider a variety of insurance plans, including health insurance, life insurance, disability insurance, homeowners or renters insurance, car insurance, and liability insurance. Evaluate your insurance needs depending on your lifestyle, financial commitments, and risk tolerance, and make sure you have enough coverage to protect your assets and prevent unforeseen disasters.

9. Long-term Planning: Plan for the long term as a pair by tackling crucial financial issues, including retirement, estate, and legacy planning. Create a retirement savings plan to assure financial security in your later years. Make an estate plan, including your wealth distribution preferences, guardianship of dependents, and healthcare instructions. Consider philanthropic aspirations and charity donations as part of your legacy strategy.

10. Regular Reviews and Communication: Regularly assess your financial status as a couple and talk freely about any changes, issues, or opportunities that emerge. Schedule monthly financial check-ins to keep track of your budget, monitor your investment portfolio, evaluate your debt payback progress, and change your financial strategy as necessary. Celebrate your financial milestones and triumphs together, and help one another through disappointments and struggles.

Managing finances as a partnership is a collaborative and continuing process that includes open communication, a common vision and goals, budgeting, financial planning, debt management, savings and emergency funds, investing, insurance, long-term planning, and frequent evaluation and discussion. Couples that work as a team and prioritize financial stability can lay the groundwork for a successful business empire and reach their shared financial objectives.

Chapter 5

Building Your Brand

Building your brand is an essential part of establishing a successful business empire as a pair. Your brand embodies your company's identity, beliefs, and reputation, and it is crucial in attracting clients, establishing trust, and distinguishing yourself from competition.

Here is a full and comprehensive strategy for developing your brand:

1. Define Your Brand Identity: Begin by creating your brand identity as a partnership. Consider your company's purpose, vision, values, and unique selling proposition. What distinguishes your business? What do you intend for your brand to represent? Define your brand's personality, voice, and tone to maintain consistency in your message and consumer interactions.

2. Understanding Your Target Audience: Develop a thorough grasp of your target audience's demographics, preferences, requirements, and pain areas. Conduct market research and consumer surveys to learn about your target market's behavior and

preferences. This information may be used to efficiently adjust your brand's messaging, goods, and services to your target audience's wants and preferences.

3. Create a compelling brand story: Create a compelling brand narrative that speaks to your target audience and represents your beliefs and aspirations as a pair. Your brand narrative should tell the tale of your company's journey, passion, and purpose, engaging with customers on an emotional level while driving loyalty and engagement.

4. Design Your Visual Identity: Create a consistent visual identity for your brand that includes your logo, colors, typography, and images. Your visual identity should represent your brand personality and appeal to your target audience. Collaborate with a professional graphic designer to produce high-quality images that exude professionalism, creativity, and authenticity.

5. Create a Strong Online Presence: Create a strong online presence for your brand through many digital channels, such as your website, social media platforms, and online marketplaces. Create a professional website that highlights your brand's story, goods, and services. Engage your audience on social media by offering useful material, replying to comments, and developing connections with followers.

6. Deliver a Consistent Brand Experience: Make sure your brand experience is consistent across all touchpoints, such as your website, social media, customer service, packaging, and marketing materials. Consistency fosters trust and solidifies your brand's identity in the eyes of your target audience. Define brand guidelines that explain your brand's characteristics, and use criteria to ensure consistency in your branding activities.

7. Provide outstanding customer service: Offer outstanding customer service that matches your brand's values and builds strong customer connections. Listen to customer input, respond to concerns swiftly, and go above and beyond to surpass customer expectations. Positive customer experiences help to develop a strong brand reputation and encourage word-of-mouth recommendations.

8. Differentiate Your Brand: Set your brand apart from the competition by emphasizing its distinctive strengths, values, and products. Determine what distinguishes your company from others in your field, and communicate this distinction effectively to your target audience. Emphasize your USP in your branding efforts to attract clients who understand your unique value proposition.

9. Engage with Your Community: Create a strong sense of community around your brand by interacting with your target audience and attending relevant industry events, forums, and networking opportunities. Participate in conversations, provide key

ideas, and offer help and resources to build meaningful connections with your customers, partners, and other stakeholders.

10. Measure and adapt: Constantly assess and analyze the efficacy of your branding initiatives to uncover areas for enhancement and adaptation. Monitor key performance indicators (KPIs) like brand awareness, consumer engagement, and brand sentiment to assess the effectiveness of your branding strategies. Use analytical and feedback insights to update your branding strategy and improve your brand's long-term efficacy.

Developing your brand as a partnership is a multidimensional and ongoing process that involves careful preparation, creativity, and consistency. By defining your brand identity, understanding your target audience, creating a compelling brand story, designing a visual identity, building a strong online presence, delivering consistent brand experiences, providing exceptional customer service, differentiating your brand, engaging with your community, and measuring and adapting your branding efforts, you can establish a strong and memorable brand that resonates with your audience and drives business success.

Defining Your Brand Identity

Defining your brand identity is a critical step toward creating a successful business empire as a partnership. Your brand identity captures the core of your company and how you intend your audience to regard it. It covers things like your purpose, vision, values, personality, and unique selling point (USP).

Here's a thorough strategy for developing your brand identity:

Begin with Your Purpose and Vision: Communicate your company's purpose and vision as a pair. Your mission statement should concisely express the objective and basic principles of your company empire, stating what you hope to accomplish and why it is important. Your vision statement should present a vivid image of the future you hope to build together through your company ventures.

Identify Your Core Ideals: Determine the ideals that will govern your company empire and represent your views and convictions as a marriage. These values form the basis of your brand identity and impact all aspects of your business operations, from decision-making to customer interactions. Consider what is most important to you as a marriage and how you wish to reflect these beliefs in your business procedures.

Define your unique selling proposition (USP): Determine what distinguishes your company from the competition and why customers should prefer you over alternatives. Your USP should emphasize the distinct advantages or value propositions that you provide to your target audience. Identify your company's unique qualities, skills, or specialty that will appeal to your potential consumers.

Establish Your Brand Personality: Identify the personality attributes that distinguish your brand and how you want your target audience to view it. Consider qualities like friendliness, professionalism, innovation, trustworthiness, or adventure. Your brand personality influences the tone and style of your communication, branding materials, and customer interactions, allowing you to establish emotional connections with your target audience.

Craft Your Brand Story: Create a captivating brand story that highlights the adventure, passion, and purpose of your couple's company empire. Your brand narrative should connect with your target audience and elicit emotions consistent with your brand identity. Share personal tales, experiences, and milestones that demonstrate the principles and vision that guide your business path together.

Create a Visual Identity: Create a consistent visual identity for your brand that represents its identity and appeals to your target audience. This covers things like your logo, colors, typography, and pictures. Your visual design should be consistent across all branding materials and communication platforms, strengthening your brand identity and providing a memorable and coherent brand experience for your target audience.

Align Your Brand Messaging: Make sure your brand's messaging is consistent across all communication channels and contact points. Your brand message should represent your business's identity, values, and personality, communicating with your target audience and presenting a consistent brand story. Consistent messaging promotes brand awareness and strengthens your brand identity in the eyes of your target audience.

Embrace Authenticity: Your branding efforts as a marriage should be authentic and genuine. Authenticity instills confidence and trustworthiness in your audience, generating deeper connections and commitment. Incorporate your unique opinions, experiences, and insights into your brand communication, exhibiting openness and authenticity in your interactions with customers.

Evolve and Adapt: Your brand identity changes over time as your company develops and matures. Continuously analyze and modify your brand identity to ensure that it stays relevant and in line with

your changing values, goals, and consumer preferences. Stay open to criticism, insights, and possibilities for growth, and be willing to change your brand identity as needed to stay loyal to your vision and effectively connect with your target audience.

Defining your brand identity as a couple is a collaborative and creative process that includes articulating your mission and vision, identifying core values, defining your unique selling proposition, establishing your brand personality, crafting your brand story, designing a visual identity, aligning your brand messaging, embracing authenticity, and evolving and adapting over time. By creating a clear and appealing brand identity, you can build a powerful and memorable brand that connects with your target audience and drives your company's success.

Developing a Marketing Strategy

Creating a marketing plan is an essential part of establishing a successful business empire as a partnership. A well-defined marketing plan enables you to reach your target audience, promote your products or services, and set your brand apart from rivals.

Here's a thorough technique for creating a marketing strategy:

1. Marketing research: Begin by completing extensive market research to better understand your target audience, industry trends, market dynamics, and competition. Gather information on your target audience's demographics, interests, behaviors, pain areas, and purchasing habits. Examine your rivals' marketing strategy, strengths, weaknesses, and market positioning to uncover opportunities and risks in the marketplace.

2. Targeted Audience Segmentation: Segment your target audience according to key factors such as demographics, psychographics, geographic region, and purchase habits. Customize your marketing messaging, offers, and platforms to successfully reach and engage each group of your target market. Create comprehensive buyer personas to reflect your ideal clients and drive your marketing strategy.

3. Value proposition: Define and express your unique value proposition (UVP) to set your brand and services apart in the marketplace. Clearly communicate the benefits, features, and value that your products or services provide to your intended audience. Highlight what distinguishes you from the competition and why buyers should prefer your brand over alternatives.

4. Brand Message: Create a consistent and appealing brand message that connects with your target audience while also communicating your business's personality, beliefs, and unique selling point. Create clear and succinct messages that meet your target audience's requirements, desires, and pain areas. To increase brand awareness and trust, ensure that your messaging is consistent across all marketing platforms and touchpoints.

5. Marketing Channels: Identify the most successful marketing channels for reaching your target demographic and meeting your marketing goals. Consider combining online and offline marketing channels, such as social media, email marketing, content marketing, search engine optimization (SEO), pay-per-click (PPC) advertising, and website optimization, with traditional marketing channels like print advertising, direct mail, events, and networking.

6. Content Strategy: Create a content plan that aligns with your marketing objectives and engages your target audience. Create high-quality, relevant, and meaningful content that speaks to your target

audience's requirements, interests, and pain points. Use a range of content types, including blog posts, articles, videos, infographics, podcasts, and webinars, to capture and hold your audience's attention and promote interaction.

7. Branding and Visual Identity: Make sure your branding and visual identity are consistent throughout all marketing materials and channels. To promote brand awareness and trustworthiness, use the same colors, typefaces, logos, and images on a constant basis. Create visually appealing and professional marketing materials that represent your company identity and speak to your target audience.

8. Marketing Campaigns: Plan and execute focused marketing campaigns to promote certain products, services, or projects while meeting your marketing objectives. Define campaign objectives, target audience, messaging, media, and techniques, and establish quantifiable KPIs to measure campaign success and ROI. Monitor campaign performance, evaluate data, and adjust campaigns based on insights to maximize efficacy and ROI.

9. Customer Relationship Management (CRM): Implement a CRM system to efficiently monitor and nurture customer and prospect connections. Capture and manage consumer data, monitor interactions and engagements, and segment your audience to enable tailored communication and targeted marketing initiatives. Use CRM data to better understand your customers' requirements,

preferences, and habits, and then customize your marketing activities appropriately.

10. Measurement and Analysis: Establish key performance indicators (KPIs) and metrics to assess the efficacy of your marketing initiatives and track your progress toward your marketing objectives. Use marketing analytics tools and platforms to collect data, assess performance, and learn about your audience, channels, campaigns, and ROI. Regularly evaluate and analyze marketing data to find trends, opportunities, and areas for improvement, and then adapt your marketing approach appropriately.

Creating a marketing strategy as a couple entails conducting extensive market research, segmenting your target audience, defining your value proposition and brand messaging, identifying effective marketing channels, creating engaging content, ensuring consistent branding, planning and executing marketing campaigns, implementing CRM, and measuring and analyzing marketing performance. By adopting a thorough and strategic marketing approach, you can effectively promote your products or services, reach your target audience, and collaborate to establish a successful company empire.

Leveraging Your Unique Selling Proposition

Leveraging your unique selling proposition (USP) is critical for couples creating a company empire. Your unique selling proposition (USP) is what distinguishes your company from competitors and gives customers a compelling reason to pick your products or services over alternatives.

Here's a complete and comprehensive way to utilize your unique selling point:

1. Identify Your Unique Strengths: Begin by defining the distinctive assets, qualities, and characteristics that set your company apart from rivals. Consider your skills, experience, specialty, quality, innovation, customer service, and value proposition. What distinguishes your firm in the marketplace? What distinctive benefits or advantages do you provide to your target audience?

2. Understanding Your Target Audience: Develop a thorough grasp of your target audience's needs, preferences, and pain areas. Conduct market research and customer surveys to learn what drives your target audience to buy similar items or services. Identify market gaps or unmet demands that your firm can successfully fulfill.

3. Align Your USP to Customer Needs: Make sure your USP solves a specific need or pain point that your target audience cares about. Your unique selling point (USP) should offer a clear and compelling

value proposition that speaks to your target audience and solves their primary problems or aspirations. Tailor your message to highlight how your company can solve their problems or meet their demands better than competitors.

4. Effectively Communicate Your USP Clearly explain your unique selling point in all marketing materials, branding initiatives, and consumer interactions. Create a clear and appealing message that emphasizes the distinct benefits and advantages of using your products or services. Make your unique selling proposition the major topic of your branding, advertising, website content, social media postings, and other marketing communications.

5. Differentiate Your Brand: Use your unique selling proposition (USP) to set your company apart from rivals and position it as a leader in its industry or niche. Highlight your distinctive capabilities and features that distinguish you from rivals, as well as why buyers should select your brand over alternatives. Create a powerful brand identity and visual presence that emphasizes your USP while increasing brand recognition and loyalty.

6. Deliver on Your Promise: Ensure that your company delivers on the promises stated in your USP. Provide great products, services, and customer experiences that are consistent with your USP and surpass customers' expectations. Deliver consistently high-quality, dependable, and creative solutions that reinforce your unique selling

point while also fostering trust and loyalty among your target audience.

7. Monitor and adapt. Regularly assess the success of your USP and alter your approach in response to market feedback, consumer insights, and competition developments. Stay aware of changes in client preferences, industry trends, and market dynamics, and be willing to adapt and develop your unique selling point to remain relevant and competitive in the marketplace.

8. Use Your Strengths as a Couple: Leverage your distinct abilities, skills, and views as a pair to improve your USP and differentiate your business. Identify methods to use your combined skills, experiences, and insights to add value to your consumers and increase your competitive advantage. Use your relationship as a selling feature to emphasize the distinct advantages of working with your firm as a pair.

9. Increase Brand Loyalty: Build brand loyalty and long-term consumer connections by using your unique selling point. Provide tailored experiences, prizes, and incentives that reinforce your unique selling point while encouraging repeat purchases and referrals. Create a sense of community and belonging among your consumers by engaging them with loyalty programs, unique deals, and meaningful interactions.

Leveraging your unique selling proposition is critical for couples creating a company empire. You can effectively differentiate your business, attract customers, and build a successful and sustainable business empire together by identifying your unique strengths, understanding your target audience, aligning your USP with customer needs, communicating effectively, differentiating your brand, delivering on your promise, monitoring and adapting, leveraging your strengths as a couple, and developing brand loyalty.

Chapter 6

Managing Roles and Responsibilities

Managing duties and responsibilities is an essential part of establishing a successful business empire as a couple. Clear communication, mutual understanding, and a well-defined work division are all necessary for effective collaboration.

Here's a thorough strategy for handling roles and responsibilities:

Begin with open communication: Talk openly and transparently about each partner's talents, skills, preferences, and expectations. Discuss your specific roles and duties, keeping in mind your distinct contributions to the organization. Clearly convey your personal and professional objectives in order to connect them with the overarching vision for the company empire. Recognize and use the unique talents and abilities that each partner offers to the organization. Identify the areas where each partner shines and assign duties accordingly. By using your individual abilities, you may improve efficiency, production, and overall business performance.

Clear roles: Clearly identify and discuss each partner's individual roles in the business. Create a complete list of duties and roles to ensure that everyone understands who is accountable for what.

Clarify the boundaries and expectations for each job to avoid possible disputes and guarantee responsibility. Divide work according to each partner's expertise, interests, and capabilities. When distributing duties, take into account technical skills, industry expertise, and personal preferences. This work allocation should be fluid and adaptive to changes in the corporate environment or individual situations.

Encourage Collaboration and Support: Create a collaborative atmosphere in which partners support one another's work. Check in on each other's work on a regular basis, give constructive criticism, and offer support as required. Collaboration is essential for exploiting the capabilities of both partners and guaranteeing the smooth operation of the firm.

Set clear boundaries: separate personal and professional obligations. Establish clear boundaries between corporate talks and personal time. This promotes a good work-life balance and keeps possible problems from escalating into personal relationships. Schedule frequent evaluations to evaluate the efficacy of present positions and responsibilities. Evaluate each partner's performance, identify areas for improvement, and discuss any necessary changes. A flexible strategy enables ongoing development and adaptability to changing conditions.

Contingency Plans: Prepare for anticipated business issues or disruptions. Discuss how to deal with unforeseen occurrences, including illness, personal emergencies, or task adjustments. Having contingency plans in place guarantees that the firm can continue to run successfully even under difficult conditions.

Support Personal growth: Recognize the value of personal growth for each partner. Encourage continuing learning, skill development, and professional progress. Investing in personal growth allows both partners to offer fresh ideas and talents to the firm, ensuring its long-term success. Appreciate successes Together, recognize and appreciate each partner's successes and milestones. Recognize the value of teamwork and shared achievement while establishing a company empire as a pair. Celebrating accomplishments together creates a good and supportive environment, maintaining the strength of your relationship.

Managing roles and responsibilities as a couple while building a business empire necessitates open communication, leveraging individual strengths, defining clear responsibilities, dividing tasks, encouraging collaboration and support, setting clear boundaries, reviewing and adjusting on a regular basis, planning for contingencies, supporting personal development, and celebrating accomplishments together. Couples may establish a peaceful and

successful business relationship based on collaboration and mutual support by properly managing roles and responsibilities.

Delegating Tasks Effectively

Delegating responsibilities efficiently is an important skill for couples building a company empire. Effective delegation enables partners to build on each other's skills, manage workloads effectively, and focus on high-priority activities that drive corporate success.

Here's a detailed and complete technique for successfully distributing tasks:

Understand each partner's strengths and skills: Begin by learning about each partner's talents, abilities, and areas of expertise. Identify and allocate tasks and duties that are appropriate for each partner's skills. By using each other's abilities, you may increase corporate efficiency and performance.

Clarify Expectations and Objectives: When assigning responsibilities to your partner, speak clearly about your expectations and objectives. Provide specific instructions, rules, and deadlines to ensure that everyone understands the task's objectives

and expected results. Discuss any questions or concerns up front to minimize misunderstandings and assure job completion success.

Set Clear Goals and Priorities: Create clear goals and priorities for the entire company empire, as well as for individual tasks and projects. Align job delegation with the overall aims and strategic objectives of the company. To maximize time and resources, prioritize projects according to their significance, urgency, and influence on company performance.

Delegate Authority and Decision Making: Delegate authority, decision-making duties, and tasks to your spouse to empower him or her. Trust your partner's judgment, and let them make judgments within their authorized power. Provide assistance and direction as required, but don't micromanage or second-guess their judgments.

Provide Adequate Resources and Support: Ensure that your partner has access to the resources, knowledge, and assistance required to effectively accomplish delegated duties. Provide the required tools, equipment, training, and support services to aid in job completion. Be accessible to answer questions, provide direction, and offer support as required throughout the work.

Monitor Progress and Provide Comments: On a regular basis, check on the progress of assigned tasks and provide constructive comments to your partner. Check in at major milestones to evaluate

progress, resolve any difficulties or roadblocks, and provide direction or support as required. Recognize and praise your partner's efforts and accomplishments to inspire and promote future performance.

Encourage Accountability and Ownership: Create a culture of accountability and ownership inside the company empire by keeping each partner accountable for their assigned tasks and obligations. Define accountability measures, such as deadlines, deliverables, and performance indicators, and ensure that both partners agree to fulfill them. Encourage a sense of ownership and pleasure in producing high-quality work that will reflect well on the company.

Encourage collaborative and open communication among partners while allocating duties. Create a friendly and inclusive atmosphere in which partners may openly share ideas, provide feedback, and cooperate on tasks and projects. Maintain regular communication channels to keep each other updated on progress, difficulties, and developments pertaining to given assignments.

Evaluate and Adjust Delegation Techniques: Continuously assess the success of your delegation techniques and make changes as needed based on feedback, performance, and outcomes. Consider the lessons learned from previous delegation experiences and identify opportunities for improvement. Be willing to change your

approach to delegation in order to increase efficiency, productivity, and partnership effectiveness within the company empire.

Effectively delegating tasks as a couple in the process of building a business empire requires understanding each other's strengths, clarifying expectations and objectives, setting clear goals and priorities, delegating authority and decision-making, providing adequate resources and support, monitoring progress and providing feedback, encouraging accountability and ownership, promoting collaboration and communication, and evaluating and adjusting delegation. Couples who understand the art of successful delegation may increase productivity, use each other's skills, and drive success in their business ventures together.

Balancing Work and Personal Life

Balancing work and family life is critical for couples launching a business empire. The demands of entrepreneurship might be overwhelming, but it is critical to strike a good balance between professional obligations and personal well-being in order to live a satisfying life.

Here's a complete and thorough strategy for combining work and personal life:

Establish distinct limits: Set distinct limits between business and personal life to keep one from infringing on the other. Set aside distinct times and areas for work-related tasks, and keep them separate from personal time and space. Establishing boundaries promotes structure and discipline, allowing couples to focus on work when necessary while prioritizing personal time for relaxation and renewal.

Communicate Openly and Honestly: Talk to your spouse about your work schedules, obligations, and priorities. Discuss your particular requirements, interests, and expectations for work-life balance, and work together to create mutually acceptable solutions. Share your problems, struggles, and triumphs with one another, creating a helpful and understanding environment within the partnership.

Prioritize Self-Care: In order to preserve physical, mental, and emotional health while juggling the demands of business, prioritize self-care and well-being. Make time for regular exercise, enough sleep, a good diet, and relaxing hobbies that will replenish and invigorate you. Prioritizing self-care not only improves general well-being, but it also boosts productivity and resilience in juggling work and personal obligations.

Schedule Quality Time Together: Set aside time as a pair to cultivate your relationship outside of work. Plan things that you both love and that will build your relationship, such as date evenings, weekend vacations, or shared interests. Investing in quality time together deepens your relationship, improves communication, and fosters mutual support and understanding.

Set realistic expectations: To minimize feelings of stress or burnout, set realistic expectations for work and personal responsibilities. Recognize that establishing a successful business requires dedicating time, patience, and effort, while balancing ambition with self-care and personal fulfillment. Set attainable objectives and priorities that are consistent with your beliefs and long-term vision for both your business and personal life.

Delegate jobs and share responsibility within the company empire to reduce effort and free up time for personal activities. Identify areas where each spouse may offer their abilities and knowledge,

and work together to divide chores so that both partners can maintain a work-life balance. Effective delegation enables couples to concentrate on high-impact activities while managing their time more effectively.

Practice time management: Use good time management skills to increase productivity and balance competing demands. Prioritize tasks based on urgency and significance, and set up specific time blocks for concentrated work, personal activities, and leisure. Calendars, to-do lists, and time-tracking applications may help you organize your schedule and manage professional and personal responsibilities more efficiently.

Be Flexible and Adaptive: When juggling work and personal life, remember that unforeseen problems or opportunities may come along the way. Adopt a growth mentality that encourages exploration, learning, and change as you negotiate the intricacies of entrepreneurship and interpersonal interactions. Remain open to reevaluating priorities, making appropriate changes, and devising innovative ways to preserve balance in both aspects of your life.

Seek Support and Collaboration: When it comes to balancing work and personal commitments, seek help from one another, as well as friends, family, and professional networks. Collaborate to discover solutions to similar issues, such as childcare, housework, or business responsibilities, and use each other's abilities and resources to

alleviate the workload. Surround yourself with a supportive environment that recognizes and supports the significance of work-life balance in attaining long-term success and happiness.

Combining work and personal life as a couple and building a business empire involves clear boundaries, open communication, self-care, quality time together, realistic expectations, delegation, time management, flexibility, and teamwork. Prioritizing work-life balance and cultivating your relationship alongside your entrepreneurial activities can allow you to develop a profitable company empire while also having a meaningful and harmonious personal life together.

Resolving Conflicts in the Workplace

Resolving workplace issues is critical for couples beginning their own businesses. However, the way in which disagreements are managed and resolved defines the strength and success of the relationship.

Here's a full, complete strategy for settling workplace conflicts:

1. Open Communication: Encourage open and honest communication among partners to resolve disputes as they arise. Promote an environment where thoughts, feelings, and concerns can be openly expressed without fear of judgment or punishment. Create a secure atmosphere in which both parties feel heard and

understood, enabling productive communication and conflict resolution.

2 . Active Listening: When settling a problem, use active listening to better comprehend each other's viewpoints and feelings. Listen carefully to your partner's point of view without interrupting or forming replies before they are ready. Validate their sentiments and accept their worries in order to display empathy and foster trust in the dispute resolution process.

3. Clear Misunderstandings: Clarify any misconceptions or miscommunications that may be causing the disagreement. Take the time to explain and restate crucial issues to ensure everyone understands and agrees. Avoid making assumptions or leaping to conclusions, and seek clarification as needed to successfully address underlying concerns.

4. Focus on the Solution: Change the focus from blaming and criticizing to seeking solutions that address the underlying causes of the dispute. Collaborate with your spouse to generate viable ideas and alternatives that address both of your requirements and preferences. Maintain an open mind, and be prepared to compromise and negotiate to obtain a mutually acceptable solution.

5. Seeking Common Ground: Identify common ground and shared goals to serve as a basis for conflict resolution. Concentrate on

common ground and shared ideals that bind you together as business partners. To develop a sense of togetherness and participation in dispute resolution efforts, emphasize the broad picture and the company's long-term objectives.

6. Use "I" words: Use "I" words to communicate your emotions and viewpoints without assigning blame to your spouse. To prevent raising tensions or provoking defensive responses, frame your words in terms of your own thoughts, feelings, and experiences. Express your frustration when deadlines are missed by saying, "I feel frustrated when deadlines are missed," instead of accusing someone of always missing deadlines.

7. Managing Emotions: Manage your emotions properly when settling arguments in order to avoid escalation and maintain a positive discourse. Even if you disagree or are frustrated, maintain your composure and respect. Take breaks as needed to cool off and gather perspective before returning to the debate.

8. Agree to Action Steps: Once you have achieved a resolution, agree on specific action steps and follow-up procedures to ensure proper implementation of the solution. Assign clear duties and dates for completing agreed-upon tasks, and track progress toward resolution. Check in with each other on a regular basis to assess the success of the solution and make any necessary modifications.

9. Forgive and let go: Once the disagreement is resolved, practice forgiveness and release any lingering bitterness or grudges. Recognize that disputes are an unavoidable part of every relationship, and concentrate on moving forward with a renewed sense of collaboration and understanding. Release negative emotions and old grudges in order to establish good and helpful collaboration within the company empire.

10. Learn and grow: Consider confrontations as chances for learning and progressing within the company empire. Examine the underlying causes and dynamics of disputes to uncover areas for reform and growth. Use conflict resolution experiences to improve communication skills, emotional intelligence, and resilience as business partners.

Resolving workplace conflicts as a couple starting a business requires open communication, active listening, clarifying misunderstandings, focusing on solutions, seeking common ground, using "I" statements, managing emotions, agreeing on action steps, forgiving and letting go, and learning and growing together. Couples who handle problems with sensitivity, teamwork, and a dedication to finding mutually beneficial solutions may deepen their relationship and create a successful and peaceful economic empire together.

Chapter 7

Cultivating a Supportive Environment

Creating a supportive environment is critical for couples launching a business empire. A supportive atmosphere promotes cooperation and invention and deepens couples' relationships as they manage the obstacles and possibilities of business.

Here's a thorough way to create a helpful environment:

1. Open Communication: Encourage open and honest communication among partners to foster a positive environment inside the company empire. Encourage the honest expression of thoughts, feelings, and ideas, and provide a comfortable environment for open discourse. Communication is essential for establishing trust, resolving issues, and maintaining a healthy relationship as you work to develop a successful business empire together.

2. Embrace a Growth Mindset: Adopt a growth mentality that emphasizes ongoing learning, progress, and adaptability. Encourage exploration, creativity, and innovation throughout the company empire, and see setbacks as chances for development and learning. Cultivate a climate in which errors are viewed as learning

opportunities rather than failures and in which partners encourage one another to take measured chances and pursue new opportunities.

3. Celebrate Your Achievements: Celebrate successes and milestones within the company empire to recognize and thank both partners' hard work and devotion. Recognize individual efforts and triumphs, as well as group achievements, that contribute to the company's development and success. Celebrating successes creates a pleasant and supportive environment that encourages partners to continue striving for greatness.

4. Offer emotional support: Provide emotional support and encouragement to your spouse while they face the ups and downs of business. Recognize the emotional toll that creating a company empire may take, and be there to lend a listening ear, a shoulder to rely on, and words of encouragement when required. Validate your partner's emotions and experiences, and provide comfort and support at difficult moments.

5. Share tasks: Distribute tasks and workload within the company empire to reduce burdens and provide a supportive environment for both partners. Divide chores and responsibilities among partners depending on their respective talents, skills, and interests. Avoid taking on the full task alone, and instead include your spouse in decision-making, problem-solving, and planning to develop a sense of ownership and cooperation in the firm.

6. Provide constructive feedback. Give your partner constructive criticism to help them grow and improve inside the company empire. Provide comments in a courteous and helpful manner, emphasizing specific habits or actions rather than personal characteristics. Praise your partner for their strengths and successes while also providing constructive feedback to help them learn new abilities and enhance their performance.

7. Develop a healthy work-life balance. Prioritize work-life balance to foster a positive atmosphere that supports overall health and happiness. Encourage one another to take pauses, emphasize self-care, and strike a good balance between work and personal life. Respect each other's limits and needs outside of work, and make quality time together a priority to strengthen your relationship and replenish your batteries.

8. Lead by Example: As business partners, you may set a good example by displaying the values and behaviors you want to see in your firm. Model helpful, courteous, and collaborative conduct in your dealings with coworkers and employees. Demonstrate empathy, kindness, and integrity in your acts, and motivate others to follow your example in building a supportive atmosphere inside the business empire.

9. Increase Diversity and Inclusion: Encourage diversity and inclusion within the business empire to foster a positive atmosphere

that recognizes and respects differences. Accept a variety of thinking, backgrounds, and viewpoints, and provide opportunities for all workers to contribute their unique skills and views to the company's success. Foster an inclusive culture in which everyone feels appreciated, respected, and empowered to thrive.

10. Get feedback and improve: Request input from your partners and staff on how to develop and strengthen the supportive atmosphere inside the company empire. Request feedback on what is functioning effectively and what can be enhanced, and be open to making adjustments based on that feedback. Continue to improve the supporting environment by integrating new ideas, projects, and practices that promote cooperation, creativity, and growth.

Creating a supportive environment within the company empire is critical for couples establishing a business jointly. Couples can create a positive and supportive environment that encourages collaboration, innovation, and success in building a thriving business empire together by fostering open communication, embracing a growth mindset, celebrating accomplishments, providing emotional support, sharing responsibilities, offering constructive feedback, promoting work-life balance, leading by example, promoting diversity and inclusion, and seeking feedback and improvement.

Celebrating Milestones Together

Celebrating milestones together is an important element of creating a successful business empire as a couple. It is an occasion to recognize and honor accomplishments, advances, and victories throughout the business path.

Here's an in-depth and complete way to celebrate milestones together:

Acknowledge and celebrate your progress as a pair in developing your company's empire. Consider the milestones you've achieved, such as meeting a revenue goal, releasing a new product or service, landing a key customer, or overcoming a significant hurdle. Recognize the hard work, commitment, and persistence that have led to your accomplishment thus far.

Celebrate minor wins: Recognize the minor victories and accomplishments that may appear insignificant but represent substantial progress in your entrepreneurial path. Whether you're finishing a project ahead of schedule, receiving favorable feedback from a customer, or mastering a new skill, take the time to recognize and enjoy these accomplishments together. Recognizing and celebrating little victories promotes morale, drive, and momentum across the corporate empire.

Mark key milestones: Commemorate key milestones and successes with unique celebrations or rituals that have particular significance for you as a pair. Find meaningful ways to celebrate milestones together, whether it's the anniversary of your company's start, hitting a certain sales milestone, or completing a large project. Consider organizing a special dinner, a team outing, or a weekend retreat to commemorate and reflect on your accomplishments.

Share Your Success with Stakeholders: Share your accomplishments and milestones with workers, clients, investors, and business partners. Recognize their efforts and celebrate your success as a team. Consider throwing a celebratory gathering, making a company-wide statement, or acknowledging individual efforts with awards or recognition programs. Sharing achievements with stakeholders promotes camaraderie, pride, and ownership within the company empire.

Express Gratitude: Take time to thank and appreciate each other for your efforts toward the success of the company empire. Recognize your mutual support, encouragement, and sacrifices along the journey. Express your appreciation for your partner's devotion, hard work, and unshakable commitment to creating a business empire together. Celebrate your partnership and the trip you've taken together with gratitude and admiration.

Reflect on successes: Consider your successes and milestones as a pair and celebrate how far you've gone from the start of your company's empire. Take some time to reflect on the struggles you've faced, the lessons you've learned, and the progress you've seen along the way. Celebrate your strength, perseverance, and capacity to overcome challenges as a team.

Set new objectives: Use milestone celebrations to establish new objectives and aspirations for the future of your company empire. Reflect on your previous accomplishments and use them as motivation to establish ambitious but attainable objectives for the next stage of your business career. Celebrate the exhilaration of new beginnings and the opportunities that await you as you continue to create and expand your business empire together.

Celebrating achievements together is a vital aspect of creating a corporate empire as a partnership. It allows you to recognize progress, celebrate triumphs, share success with stakeholders, show thanks, reflect on accomplishments, and establish new goals for the future. Celebrating achievements together may help couples enhance their relationship, raise morale, and foster a good and supportive environment inside the company empire.

Nurturing a Positive Work Culture

Fostering a healthy work culture is critical for couples building a business empire. A healthy work culture promotes employee engagement, creativity, productivity, and contentment, all of which are critical to the company's success and long-term viability.

Here is a full and comprehensive strategy for cultivating a great workplace culture:

Lead by example: As business owners and partners, demonstrate the values and behaviors you want to see in the organization. When interacting with colleagues and partners, demonstrate positivism, honesty, respect, and teamwork. Show your appreciation for others' efforts and accomplishments, and foster a friendly and inclusive workplace in which everyone feels valued and appreciated.

Communicate Openly and Transparently: Encourage open and transparent communication inside the organization to foster trust and transparency. Encourage staff to openly discuss their opinions, ideas, and concerns, and offer frequent updates on business performance, objectives, and projects. Create opportunities for two-way communication by holding frequent team meetings, one-on-one conversations, and feedback sessions. Encourage collaboration and teamwork among employees to develop a sense of togetherness and camaraderie inside the business. Encourage staff to collaborate on

projects, share expertise and resources, and assist one another in reaching shared objectives. Recognize and celebrate team successes to emphasize the value of collaboration and teamwork in achieving success.

Empower and Develop Employees: Give employees autonomy, responsibility, and opportunity for growth and development. Encourage workers to take ownership of their jobs and make autonomous decisions in their areas of competence. Provide workers with access to training, tools, and mentoring programs to help them develop professionally and succeed in their careers.

Recognize and recognize individuals for their efforts and accomplishments within the organization. Celebrate individual and team successes, such as meeting sales objectives, finishing projects on schedule, or exhibiting superior performance. Show appreciation for workers' hard work and devotion by providing praise, incentives, and awards.

Promote Work-Life Balance: Encourage work-life balance by providing flexible work arrangements, paid time off, and wellness programs that benefit employees' overall health. Encourage staff to emphasize self-care, spend time with their families, and explore personal interests outside of work. Respect workers' limits and provide them time to rest and rejuvenate outside of work hours. Create a pleasant physical environment: Establish a pleasant

physical environment in the workplace that promotes productivity, creativity, and well-being. Create a comfortable and ergonomic office with plenty of natural light, vegetation, and spaces for collaboration and leisure. Provide amenities like nutritious food, comfortable seats, and recreational facilities to improve employee comfort and happiness.

Encourage diversity and inclusion inside the organization by cultivating a culture that recognizes and respects differences. Create a friendly and inclusive atmosphere in which workers from all backgrounds feel appreciated, respected, and empowered to share their unique ideas and abilities. Implement policies and programs that encourage diversity while addressing workplace prejudice and discrimination.

Encourage comments and continuous improvement: Encourage workers to provide comments on how to enhance the organizational culture and environment. Collect feedback on what is effective and what can be improved, and then promptly address staff concerns and recommendations. Encourage a culture of continuous improvement where we appreciate input and implement adjustments to enhance the work experience for everyone. Celebrate wins and milestones within the organization to acknowledge employees' efforts and accomplishments. Organize frequent celebrations, such as team lunches, happy hours, or awards ceremonies, to recognize individual

and team achievements. Celebrating victories promotes a sense of pride, drive, and belonging inside the business.

Cultivating a pleasant work culture is critical for couples launching a company empire. Couples can foster a supportive, inclusive, and thriving work culture within their organization by setting a good example, communicating openly and transparently, encouraging collaboration and teamwork, empowering and developing employees, recognizing and rewarding accomplishments, promoting work-life balance, creating a positive physical environment, promoting diversity and inclusion, encouraging feedback and continuous improvement, and celebrating successes and milestones.

Seeking Outside Support When Needed

Seeking outside assistance when necessary is an essential component of developing a successful business empire as a partnership. While couples may have a strong relationship and the same vision, they may face problems or demand knowledge that exceeds their separate skill sets. Seeking outside assistance may provide significant resources, direction, and views for overcoming hurdles and navigating the intricacies of business.

Here's a full and complete strategy for requesting external assistance:

1. Identify Areas of Need: Begin by finding places where outside assistance may be advantageous to your company's empire. Consider your combined strengths and limitations, as well as any special hurdles or gaps in knowledge, skills, or resources that you may face along the way. Entrepreneurs often seek outside assistance for financial management, legal advice, marketing experience, strategic planning, and industry-specific knowledge.

2. Research and evaluate options. Investigate and analyze any outside sources of help that meet your couple's needs and aspirations. Consider getting help from a variety of sources, including business consultants, industry experts, mentors, coaches, professional advisers (such as accountants and attorneys),

networking clubs, and entrepreneurial organizations. Take the time to properly examine each choice, considering their credentials, experience, and track record, and determining how their skills may help your company's empire.

3. Establish a Support Network: Create a broad and comprehensive support network of individuals and organizations to provide direction, counsel, and help as required. Develop relationships with mentors, advisers, and fellow entrepreneurs who can share their experiences and give advice and encouragement along the journey. Networking events, industry conferences, and online groups may all help you build your support network and connect with others who share your interests.

4. Engage with expert services: Consider hiring expert help to handle certain issues within your company empire. For example, you may hire an accountant to manage your finances, a lawyer to handle legal issues, or a marketing firm to create and implement marketing plans. Professional services can offer specialized expertise and support in areas where you may lack experience or understanding, allowing you to make informed decisions and manage complicated challenges more efficiently.

5. Seek advice from mentors and coaches. Seek help from mentors and coaches who can offer individualized support and advice based on your unique needs and issues. Mentors may provide insight,

direction, and encouragement based on their own experiences and knowledge, whereas coaches can provide organized guidance and accountability to help you define and achieve your objectives. Look for people who have succeeded in your sector or subject of interest and are eager to share their knowledge and ideas with you.

6. Engage in peer learning opportunities: Participate in peer learning events, such as mastermind groups, peer advisory boards, or entrepreneurship forums, where you may work with other couples and entrepreneurs experiencing similar issues. Peer learning creates a friendly atmosphere in which people may share ideas, seek advice, and learn from one another's experiences. Engaging with peers allows you to acquire useful ideas, receive criticism, and tap into a common body of knowledge and expertise to help your business develop and succeed.

7. Remain open to learning and growth: Stay open to learning and progress by seeking outside assistance as needed throughout your entrepreneurial journey. Recognize that requesting outside assistance is not a sign of weakness but rather a proactive move toward establishing a strong and resilient corporate empire. Be open to comments, guidance, and new ideas, and be prepared to adapt and change in the face of changing circumstances and problems. By being open to learning and improvement, you may use outside

assistance to overcome hurdles, capture opportunities, and realize your goals as a pair in developing a successful business empire.

Getting outside assistance when necessary is a crucial component of developing a successful business empire as a pair. Couples can navigate the complexities of entrepreneurship and achieve success by identifying areas of need, researching and evaluating options, building a support network, engaging with professional services, seeking guidance from mentors and coaches, participating in peer learning opportunities, and remaining open to learning and growth.

Chapter 8

Scaling Your Business

Scaling your business is an important step in the process of creating a business empire as a partnership. It entails extending your operations, boosting your market presence, and improving income and profitability in order to achieve long-term success and sustainability.

Here is a complete and comprehensive way to grow your business: Assess your preparation:

Before you begin the process of growing your business, consider your preparation as a couple and as a corporate organization. Assess your financial health, operational efficiency, market position, and organizational ability to support growth and development. Consider available resources, infrastructure, technology, and talent when determining your scaling preparedness.

Define Your Growth Strategy: Create a clear and actionable growth strategy that reflects your couple's vision, goals, and values. Determine your target market categories, growth possibilities, and strategic goals for expansion. Determine the most successful and long-term strategies to expand your firm, whether via organic

growth, strategic alliances, acquisitions, or diversification into new markets or product categories.

Invest in Infrastructure and Technology: Make sure your company has the infrastructure and technology it needs to develop and expand. Upgrade your operational systems, procedures, and technology platforms to improve scalability, efficiency, and performance. Invest in scalable technologies that can handle rising demand, simplify operations, and support future expansion plans.

Focus on the customer experience: Make the customer experience a primary driver of development and retention in your company's empire. Invest in providing excellent products, services, and experiences that meet or exceed customers' expectations. Listen to consumer input, get insights, and constantly improve your services to increase customer happiness and loyalty.

Build a High-Performance Team: Create a high-performing team capable of driving your company's development and expansion. Hire excellent individuals that share your beliefs, goals, and culture as a pair. Invest in employee training, development, and engagement programs to create a motivated, talented, and cohesive staff capable of carrying out your growth strategy successfully.

Expand your market reach by focusing on new consumer categories, geographic locations, or distribution methods. Identify untapped

market potential and create strategies for expanding and capturing market share in new regions. Consider strategic collaborations, alliances, or distribution agreements to broaden your market reach and attract new clients.

Optimize your business's operations and procedures to increase efficiency, save expenses, and enhance scalability. Improve productivity and performance by streamlining procedures, eliminating inefficiencies, and using automation and technological solutions. Continuously analyze and adjust your operations to guarantee they can scale efficiently as your company expands.

Secure Financing and Resources: Ensure that your company has the funding and resources it needs to develop and expand. To support your expansion activities, consider several funding choices, such as bank loans, lines of credit, venture capital, and angel investment. Allocate resources carefully to support your expansion ambitions, whether through marketing, sales, R&D, or infrastructure.

Monitor Performance and change: As your firm grows, keep a careful eye on its performance and be ready to change and pivot as needed. Track key performance indicators (KPIs) for revenue, profitability, client acquisition, retention, and operational efficiency. Analyze data and insights to uncover trends, opportunities, and areas for improvement, and then modify your strategy and tactics appropriately.

Maintain Focus and Discipline: Stay focused and disciplined as you grow your business, and avoid spreading yourself too thin. Maintain your basic beliefs, vision, and aspirations as a marriage, and prioritize projects that support your long-term ambitions. Avoid the temptation to pursue expansion at any cost and instead adopt a disciplined approach to decision-making, resource allocation, and risk management.

Growing your business as a pair needs meticulous planning, smart execution, and disciplined management. You can successfully scale your business and create a thriving business empire by assessing your readiness, defining a growth strategy, investing in infrastructure and technology, focusing on customer experience, building a high-performance team, expanding your market reach, optimizing operations and processes, securing financing and resources, monitoring performance, and maintaining focus and discipline.

Scaling Strategies for Couples

Scaling a business as a partnership necessitates a deliberate approach that capitalizes on your distinct abilities, resources, and interpersonal dynamics.

Here's a thorough review of scaling options for couples:

1. Use your complementary skills: Couples frequently bring diverse talents and qualities to the table. Use these complimentary talents to efficiently manage and grow your firm. For example, one partner may excel in sales and marketing, while the other specializes in operations and finance. By identifying and exploiting each other's abilities, you may efficiently split duties and create development across the firm.

2. Create a Strong Support System: Growing a business may be difficult, both personally and professionally. Create a robust support structure of mentors, advisers, and other entrepreneurs who can offer advice, support, and encouragement. Lean on one another for support and inspiration during difficult times, and seek outside assistance as necessary to overcome hurdles and negotiate the intricacies of developing your firm.

3. Focus on Scalable Business Models: When growing your firm, prioritize scalable business models that can expand quickly without requiring a commensurate increase in resources. Consider using

technology and automation to streamline procedures, increase productivity, and grow your operations successfully. Look for ways to broaden your presence and consumer base without dramatically raising overhead expenditures.

4. Prioritize the customer experience: As your company grows, consider providing excellent customer experiences to increase client happiness, retention, and loyalty. Invest in developing close connections with your consumers, learning about their wants and preferences, and providing products and services that surpass their expectations. Customers who are happy and pleased are more likely to return and become brand champions, which contributes to long-term success.

5. Develop a growth mentality: As a pair, cultivate a growth mentality to accept difficulties, learn from setbacks, and constantly improve as your business grows. Adopt an entrepreneurial attitude that values innovation, creativity, and flexibility, and be prepared to experiment, take chances, and pivot when necessary to capitalize on opportunities and overcome barriers. Approach expanding your business as a learning experience, and be open to criticism, new ideas, and various viewpoints.

6. Invest in Talent: Scaling a firm sometimes necessitates increasing your crew to accommodate growth and increased effort. Invest in recruiting, maintaining, and developing outstanding personnel who

share your company's culture, values, and vision. Hire people who are not just competent and experienced but also enthusiastic about your company and dedicated to its success. Invest in continuing training, development, and mentoring to empower your staff and allow them to contribute to your company's growth and success.

7. Establish scalable systems and processes: As you build your firm, create scalable systems and procedures to enable growth and expansion. Streamline operations, standardize procedures, and use technology to increase efficiency, productivity, and scalability. Automate tedious activities, use cloud-based technologies, and employ data analytics to get insights and make educated decisions that will drive growth and improve performance.

8. Remain Agile and Flexible: In a continuously changing business climate, it is critical to remain nimble and flexible as you grow your company. Prepare to adjust and pivot in response to market changes, client input, and emerging trends. Stay up-to-date on industry advancements, competition activity, and consumer preferences, and be prepared to adapt your strategy and tactics as needed to stay ahead of the curve and capitalize on growth prospects.

9. Track Key Performance Indicators (KPIs): Efficiently grow your business by tracking key performance indicators (KPIs) that align with your company's goals and objectives. Metrics like revenue growth, client acquisition cost, customer lifetime value, churn rate,

and profitability may help you analyze the efficacy of your scaling strategy and identify areas for improvement. Use data and analytics to create data-driven decisions that promote growth and improve performance as your company grows.

10. Celebrate Milestones and Achievements: As you grow your business as a pair, remember to celebrate milestones and triumphs along the way. Recognize and appreciate your progress, the obstacles you've conquered, and the accomplishments you've achieved together. Celebrate as a team, whether you're hitting a sales milestone, releasing a new product, or entering a new market, and utilize these opportunities to reflect on your path and reaffirm your resolve to build a great business empire together.

Expanding a business as a pair necessitates a deliberate and collaborative approach that capitalizes on your respective abilities, resources, and relationship dynamics. Couples can effectively scale their business and build a successful business empire by focusing on scalable business models, prioritizing customer experience, cultivating a growth mindset, investing in talent, establishing scalable systems and processes, remaining agile and flexible, monitoring KPIs, and celebrating milestones and successes.

Outsourcing and Delegating as You Grow

As your firm expands, outsourcing and delegation become critical tactics for managing workloads, increasing efficiency, and focusing on core business tasks. Outsourcing is hiring external parties or agencies to execute certain activities or duties, whereas delegation entails allocating responsibility to internal team members or partners.

Here's a complete and comprehensive method for outsourcing and delegating as you expand your company's empire as a couple:

Identify Core Competencies: Begin by determining your core competencies as a marriage and a business. Identify the core operations and tasks that are critical to your company's performance and should be kept in-house. These core abilities usually involve strategic planning, decision-making, fundamental company operations, and tasks that directly contribute to your competitive advantage or value offer.

Evaluate non-core tasks: Determine whether non-core tasks and functions may be outsourced or assigned to external parties or within teams. Non-core activities are actions that are required for business operations but have no direct impact on your company's competitive edge or value proposition. Administrative duties, normal operations,

specialized services, and jobs requiring unique knowledge or resources that are not accessible in-house are all examples.

Assess Outsourcing Opportunities: Assess if external parties or agencies can efficiently handle non-core operations. When considering possible outsourcing partners, consider costs, experience, service quality, scalability, and flexibility. Research and vet possible suppliers, agencies, or freelancers to verify they meet your company's requirements, values, and quality standards.

Delegate responsibilities. Internally, assign duties to your team members or partners depending on their talents, knowledge, and capabilities. Assign assignments and projects that are appropriate for their abilities and interests, and provide clear objectives, standards, and completion dates. To guarantee successful execution, empower your team members to accept responsibility for their roles and foster open communication and cooperation.

Communicate Effectively: Effective communication is critical when outsourcing and delegating jobs to expand your business empire. Communicate your goals, requirements, and objectives to external partners, vendors, or freelancers so that they understand their roles and duties. Provide frequent updates, comments, and coaching to internal team members to help them improve and succeed in accomplishing assigned tasks.

Establish explicit procedures: Create explicit procedures and workflows for outsourcing and delegating jobs to ensure efficiency, consistency, and quality. Define roles and duties, establish clear expectations and standards, and implement communication protocols and feedback systems to ensure seamless cooperation and execution. Document processes and procedures to serve as a guide and reference for internal and external parties involved in outsourced or delegated duties.

Monitor Performance and Quality: Check the performance and quality of outsourced and delegated jobs to ensure they match your standards and expectations. Regularly review progress, analyze outcomes, and provide feedback to external partners and internal team members to promptly address any issues or concerns. Create key performance indicators (KPIs) and metrics to assess the efficacy and influence of outsourcing and delegating tasks on your company's performance and success.

Analyze and adjust: As your firm grows, you should constantly analyze the success of outsourcing and delegating operations. Evaluate the effects on productivity, efficiency, cost-effectiveness, and overall business performance. Identify areas for improvement, adapt your strategy as appropriate, and look into new prospects for outsourcing or delegating chores to further streamline your business

operations while focusing on generating development and innovation as a pair.

As your firm grows, you may maximize efficiency, use external knowledge and resources, and devote more time and attention to strategic objectives and core business operations by efficiently outsourcing and delegating duties. This enables you to efficiently expand your firm, generate development, and achieve long-term success as a pair while developing your business empire together.

Planning for Long-Term Sustainability

Planning for long-term sustainability is critical for couples beginning a business empire. It entails developing a strategy plan to assure the long-term survival, resilience, and growth of the firm. Here's a detailed and complete strategy for planning long-term sustainability:

1. Define Your Vision and Mission: Begin by creating a clear vision and objective for your company's empire as a pair. Your vision describes your long-term ambitions and goals, whereas your mission specifies the purpose and values that govern your company's activities and decisions. Aligning on a common vision and goal gives a good platform for developing and implementing long-term sustainability plans.

2. Conduct a SWOT analysis: Conduct a thorough SWOT analysis (Strengths, Weaknesses, Opportunities, Threats) to evaluate your company's internal capabilities and external environment. Identify your relationship and business's strengths and weaknesses, as well as market opportunities and dangers. This research allows you to better understand your competitive position, identify areas for development, and capitalize on chances for long-term growth and sustainability.

3. Establish clear goals and objectives. Establish precise, quantifiable goals and objectives for your company empire that are consistent with your vision and purpose. Specify, make attainable, ensure relevance, and set time-bound goals (SMART) to ensure long-term success. Consider creating short- and long-term objectives in areas like revenue growth, market expansion, customer acquisition, product development, and operational efficiency.

4. Develop a Strategic Plan: Create a detailed strategic plan outlining the strategies and activities you will use to meet your long-term goals and objectives. This strategy should cover all parts of your company, including marketing, sales, operations, finance, human resources, and technology. Define specific action stages, dates, and milestones for implementing your strategic initiatives, and monitor progress on a regular basis.

5. Focus on innovation and adaptability. Prioritize innovation and flexibility as critical drivers of long-term sustainability. Continuously innovate and improve your products, services, and processes to remain ahead of market trends, fulfill changing client wants, and maintain a competitive advantage. Create a culture of creativity, experimentation, and learning throughout your company empire to encourage innovation and flexibility at all levels.

6. Create strong relationships: Strengthen relationships with consumers, suppliers, partners, and other stakeholders to ensure long-term viability. Concentrate on providing excellent client experiences, establishing trust and loyalty, and communicating openly with your stakeholders. Establish mutually beneficial connections and alliances that will help your company expand and thrive in the long run.

7. Invest in personnel and development: Invest in hiring, developing, and keeping elite personnel to ensure the long-term viability of your company empire. Hire people who share your values, vision, and dedication to excellence, and offer chances for continuous training, growth, and progress. Empower your team members to use their talents, creativity, and knowledge to help you achieve your long-term goals and objectives as a team.

8. Implement Effective Risk Management: Implement effective risk management procedures to detect, evaluate, and minimize threats to your company's long-term viability. Regular risk assessments may help you discover possible dangers to your firm, such as market swings, regulatory changes, competitive pressures, or operational issues. Create contingency plans and techniques to proactively manage risks and reduce their impact on your business operations.

9. Ensure financial health and stability: Maintain financial health and stability by managing your money wisely and intelligently.

Establish effective financial management procedures, such as budgeting, forecasting, cash flow management, and risk assessment. Monitor important financial parameters on a regular basis and make educated decisions to improve your financial performance and position your company for long-term success and development.

10. Monitor and measure progress. Continuously evaluate and assess your progress in meeting your long-term sustainability goals and objectives. Track key performance indicators (KPIs) that are important to your company's success, such as revenue growth, customer happiness, market share, staff engagement, and profitability. Regularly evaluate and analyze performance data to discover trends, opportunities, and areas for improvement, and then adapt your strategy and tactics accordingly.

11. Adapt and evolve. Finally, keep your flexibility and adaptability in mind as you handle the intricacies of long-term business expansion. Accept change, learn from mistakes, and be open to pivoting and adjusting your plans in response to changing market dynamics, technical breakthroughs, and external influences. By being nimble and resilient, you may position your business for long-term development and success as a pair.

Couples who are launching a company empire must prepare for long-term sustainability. Couples can create a resilient, successful, and sustainable business empire together by defining a clear vision

and mission, conducting a SWOT analysis, setting clear goals and objectives, developing a strategic plan, focusing on innovation and adaptability, building strong relationships, investing in talent and development, implementing effective risk management, ensuring financial health and stability, monitoring progress, and adapting and evolving over time.

Chapter 9

Overcoming Challenges Together

Couples who begin on the road to developing a business empire together sometimes confront particular hurdles as a result of the intersection of their personal and professional lives. These problems might put their relationship, communication skills, and capacity to collaborate effectively as lovers and business partners to the test.

Here are some frequent issues couples confront in business:

1. Blurred Boundaries: One of the most critical obstacles for couples in business is the blurring of personal and professional boundaries. When work and home life intersect, it can be difficult to distinguish between professional and personal conversations, resulting in possible disputes and stress.

2. Communication breakdowns: Effective communication is vital for any successful partnership, but business couples may find it difficult to maintain clear and open communication lines. Differences in communication styles, unsolved disputes, or hidden expectations can all contribute to misunderstandings and communication breakdowns, which impede cooperation and decision-making.

3. Role Confusion: Couples may struggle to establish and maintain defined roles and duties in their company. Without clearly defined responsibilities, there may be uncertainty about who is accountable for specific activities or choices, resulting in inefficiency, redundant efforts, or even animosity.

4. Conflict Resolution: Conflict is unavoidable in every connection, but it may be especially difficult for couples in business. Disagreements over corporate choices, competing priorities, or opposing work styles can lead to personal conflicts if not addressed correctly. Couples must develop healthy conflict resolution techniques to overcome differences and reach mutually accepted solutions.

5. Balancing Work and Personal Life: Balancing the obligations of running a business while maintaining a strong personal connection may be difficult for couples. The pressure to succeed in business might result in lengthy work hours, little quality time together, and neglect of personal needs or relationships outside of work.

6. Financial strain: Starting and expanding a business can put a burden on couples' finances, especially if they use personal resources or borrow money to support their endeavor. Financial stress can worsen pre-existing relationship problems while also straining communication and decision-making processes.

7. Uneven Contribution: Couples may encounter difficulties due to uneven contributions to the business. Differences in abilities, experience, or commitment levels can cause feelings of resentment or imbalance in a partnership, especially if one partner believes they bear an unfair share of the job or responsibilities.

8. Lack of Boundaries: Boundaries are vital for achieving a healthy work-life balance, but business couples may struggle to develop and keep them. This can lead to work-related stress spilling over into personal life or making it difficult to separate work-related talks and activities during free time.

9. Manage Family Dynamics: In addition, couples who work together may have to address family issues, particularly when their children or other family members are involved in the firm. Balancing the needs and expectations of family members with the duties of operating a company can complicate the relationship.

10. Resilience in the Face of Setbacks: Building a corporate empire requires dealing with inevitable setbacks and hurdles along the road. Couples must negotiate these failures together, retain resilience, and remain dedicated to their shared objectives and vision despite difficulty.

Couples in business encounter particular obstacles that require excellent communication, boundary-setting, conflict resolution, and

resilience. Couples who recognize and manage these typical issues may enhance their relationship, navigate barriers more effectively, and develop a successful business empire together.

Strategies for Resolving Disagreements

Effective conflict resolution is critical for couples embarking on a business journey together.

However, the way conflicts and disagreements are handled can either enhance or destroy the relationship. Here are some techniques for settling conflicts in business:

1. Active Listening: Engage in active listening during arguments to ensure that both partners feel heard and understood. Focus on understanding the other person's point of view without interrupting or leaping to conclusions. To display empathy and understanding, paraphrase what the other person is saying.

2. Empathy and Understanding: Approach conflicts with empathy and a sincere willingness to comprehend the opposing party's point of view. Recognize that both partners may have valid issues and opinions, and seek common ground or compromise wherever feasible. Avoid blaming or assaulting the other person, and instead work together to discover answers.

3. Clear Expectations: Clarify expectations and goals so that both parties are on the same page. Unclear expectations or assumptions can lead to misunderstandings. Take the time to discuss and agree on expectations for roles and duties, decision-making, and other facets of the business.

4. Focus on the issue, not the person. When discussing a disagreement, focus on the precise subject at hand rather than attacking the other person personally. Avoid making broad or accusatory remarks and instead focus on the specific behavior or activity that is creating concern. Separate the individual from the problem in order to promote healthy communication.

5. Seeking Common Ground: Look for areas of agreement or common ground that may be used as a starting point for problem solving. Recognize areas where you agree or share similar aims and ideals, even if you differ on exact specifics or techniques. Finding common ground can help establish rapport and trust, making it simpler to resolve issues.

6. Brainstorm Solutions: Collaborate on brainstorming alternative solutions to the conflict. Encourage creativity and open-mindedness during brainstorming sessions, allowing for the exploration of many ideas and views. Before evaluating the feasibility and efficacy of any solution, consider all of its alternatives.

7. Evaluate the pros and cons: Evaluate the benefits and drawbacks of each proposed option objectively and fairly. Consider each solution's possible influence on the business, both in the short and long term. Discuss the possible dangers, advantages, and trade-offs of each choice in order to make an informed conclusion.

8. Compromise and Flexibility: Be open to compromise and be flexible in resolving the conflict. Recognize that, in order to reach a mutually acceptable solution, both sides may have to make sacrifices or modifications. When assessing potential compromises, keep the bigger picture and the business empire's long-term goals in mind.

9. Agree to Action Steps: Once a resolution has been reached, agree on the precise next steps to carry it out. Clearly define who is in charge of each action step, the date for completion, and any other pertinent information. Ensure that agreed-upon activities are carried out by establishing accountability systems.

10. Reflect and learn. After resolving a conflict, spend some time reflecting on the situation and identifying any lessons learned. Reflect on the strengths and areas for improvement during the settlement process and apply these insights to future conflicts. Use the experience to further your personal and professional development as a business couple.

11. Seek Mediation If Necessary: If problems persist or worsen to the point where they cannot be resolved individually, seek outside mediation or professional help. A neutral third person, such as a business coach, therapist, or mediator, may assist in promoting constructive communication, identifying underlying issues, and guiding the settlement process.

Competent conflict resolution is critical for couples embarking on a business venture together. Couples can effectively navigate disagreements and strengthen their partnership by practicing active listening, empathy, and understanding, clarifying expectations, focusing on the issue, seeking common ground, brainstorming solutions, evaluating pros and cons, compromising and being flexible, agreeing on action steps, reflecting and learning, and seeking mediation if necessary.

Strengthening Your Relationship through Adversity

Strengthening your connection through difficulty is an important part of creating a commercial empire as a pair. While experiencing problems and disappointments together can be challenging, it also gives a chance for growth, resilience, and a stronger relationship as partners.

Here's a clear and complete strategy for improving your connection through difficulty:

1. Open and honest communication: Effective communication is the foundation of any successful relationship, particularly during difficult times. Be open and honest with one another about your views, feelings, and worries about the challenges you're encountering in your company's empire. Create a secure environment for open communication in which both parties feel heard and cherished.

2. Practice empathy and understanding: During difficult circumstances, demonstrate empathy and compassion for one another's opinions and experiences. Put yourself in your partner's shoes and attempt to understand things from their perspective. Validate one another's feelings and provide support and encouragement as you work through obstacles together.

3. Increase trust and resilience: Adversity can strengthen your relationship by fostering trust and resilience. Trust that you can weather the storm and overcome problems together. Trust is vital for efficient teamwork and collaboration, especially when facing challenges in your company's empire.

4. Focus on solutions, not blame. Instead of blaming others or concentrating on issues, work together to discover solutions. Approach adversity as a team, brainstorming inventive solutions to the obstacles you face in your company's empire. Collaborate on action plans and work together to make them effective.

5. Appreciate tiny wins: Recognize and appreciate tiny victories and milestones, particularly when facing difficulty. Celebrating accomplishments, no matter how minor, may increase morale and motivation, confirming your will to overcome obstacles together. Recognize each other's efforts and triumphs, instilling a spirit of respect and thankfulness in your partnership.

6. Keep a positive outlook: Maintain an optimistic view and attitude, especially when faced with hardship. A positive mentality may help you face issues with optimism and perseverance, making it simpler to overcome them together. Concentrate on what you can control and influence, rather than what is beyond your control.

7. Rely on each other for support. When things are tough, rely on one another for emotional support and encouragement. Be a source of strength and comfort for your spouse, providing reassurance and encouragement when they require it the most. Remember that you're in this together and can count on each other for support.

8. Take Care of One Another: Take care of one another's physical, emotional, and mental health during difficult times. Prioritize self-care and schedule time for things that will strengthen your relationship and provide you with joy. Check in on each other on a regular basis, offering support and assistance as required.

9. Learn and grow together: Adversity can enhance personal and interpersonal skills. Consider the problems you've encountered and the lessons you've learned as a pair. Use these experiences to enhance, deepen, and grow your relationship as business and life partners.

10. Seek professional assistance if necessary: If the struggle you're facing is negatively impacting your relationship, don't be afraid to seek professional support or therapy. A skilled therapist or counselor may offer advice, support, and solutions for overcoming obstacles and improving your relationship during difficult times.

Couples that are developing a business empire together must deepen their relationship through difficulty. Couples can effectively navigate adversity by practicing open and honest communication, empathy and understanding, trust and resilience, focusing on solutions, celebrating small wins, maintaining a positive outlook, leaning on each other for support, taking care of each other, learning and growing together, and seeking professional help if necessary.

Chapter 10

Looking to the Future

Couples who are building a business empire together must plan for the future. It entails imagining the long-term objectives, aspirations, and direction of the company, as well as forecasting possible obstacles and opportunities.

Here's a full and complete examination of looking to the future in business:

1. Long-Term Vision: Couples should start by developing a long-term goal for their business empire. This vision acts as a guiding light, articulating what they want to accomplish in the future years or decades. It incorporates their overall business aims, beliefs, and aspirations while also providing a sense of purpose and direction.

2. Couples may create strategic plans to make the long-term goal a reality through strategic planning, which includes establishing defined goals, identifying significant projects and milestones, and developing methods to attain them. Strategic planning includes establishing defined goals, identifying significant projects and milestones, and developing methods to attain them. It covers several facets of the firm, such as growth initiatives, marketing plans, operational enhancements, and financial predictions.

3. Market Analysis: Looking into the future necessitates a solid awareness of the market landscape and industry trends. Couples should perform constant market analysis to stay current on changes in client preferences, rival strategies, and upcoming technologies or breakthroughs that may affect their firm. This allows them to alter their plans and remain ahead of the competition.

4. Innovation and adaptability: Successful firms innovate and adapt to changing market conditions and consumer demands. Couples should build an innovative culture within their company empire by fostering creativity, experimentation, and constant progress. They should be willing to embrace new technology, business strategies, and concepts that may propel growth and set their company apart from the competition.

5. Risk Management: Looking forward means detecting and minimizing any dangers to the business empire's prosperity. Couples should undertake risk assessments to identify weaknesses and establish effective risk management and mitigation methods. This might entail diversifying revenue streams, developing contingency plans, or investing in insurance or risk management solutions.

6. Finance Planning: Financial planning is an essential component of looking forward in a company. Couples should create detailed financial strategies that reflect their long-term aspirations and support the expansion and sustainability of their business empire.

This involves budgeting, forecasting, managing cash flow, developing investment plans, and making capital allocation decisions.

7. Talent Development: Creating a successful corporate empire needs a competent and motivated workforce. Couples should engage in talent development efforts to recruit, retain, and develop top performers inside their firm. This might include training and development programs, performance management systems, employee appreciation campaigns, and succession planning techniques.

8. Social responsibilities: Looking to the future in business entails a dedication to social responsibility and sustainability. Couples should think about the social and environmental effects of their businesses and look for ways to have a positive influence in their communities and throughout the world. This might involve developing ethical corporate practices, supporting charity causes, or limiting their environmental impact.

9. Adaptive Leadership: Couples, as corporate leaders, should adopt adaptive leadership concepts that allow them to effectively negotiate volatility and complexity. This includes being nimble, adaptable, and sensitive to changing situations, as well as encouraging their team members to take initiative and contribute to the company's success.

10. Continuous Learning and Improvement: Finally, anticipating the future necessitates a commitment to continuous learning and progress. Couples should adopt a growth mentality and be willing to accept feedback, new ideas, and possibilities for personal and professional development. They must constantly analyze and improve their strategies, methods, and talents to ensure the long-term success and relevance of their corporate empire.

Couples who are building a business empire together must plan for the future. Couples can position their business empire for long-term success and sustainability by creating a long-term vision, developing strategic plans, conducting market analysis, fostering innovation, managing risks, planning financially, investing in talent development, embracing social responsibility, practicing adaptive leadership, and committing to continuous learning and improvement.

Setting Long-Term Goals for Your Business

Setting long-term business goals is an important step in creating a successful empire as a couple. Long-term goals provide direction, focus, and motivation for your efforts to achieve your future vision.

Here's a detailed and comprehensive approach to establishing long-term business goals: Establish a long-term vision for your business empire. This vision embodies your ultimate goals and the impact you hope to make on the world through your business. It encompasses your values, purpose, and overarching goals, serving as a guiding light for your journey together.

Identify Core Values: Identify the core values that will guide your business decisions and actions as a couple. These values reflect your beliefs, principles, and priorities as partners in both love and business. By aligning your long-term goals with your core values, you can ensure that your business empire is built on a solid foundation of integrity and authenticity.

Set SMART Goals: Set SMART (specific, measurable, achievable, relevant, and time-bound) goals that align with your long-term vision and core values. SMART goals offer clarity and accountability, ensuring that you have a clear path to achieving your objectives. Break down your long-term goals into smaller, actionable steps that you can work toward consistently.

Set long-term business goals that prioritize both growth and impact. Consider how you can grow your business sustainably while also making a positive difference in the lives of your customers, employees, and community. Aim to create value and leave a lasting legacy through your business endeavors.

Balance Short-Term and Long-Term Goals: Strike a balance between short-term and long-term goals to ensure that you're making progress towards your ultimate vision while also addressing immediate needs and opportunities. Short-term goals help you stay focused and motivated in the present, while long-term goals provide direction and purpose for the future.

Consider Different Areas of Your Business: When setting long-term goals, consider different areas of your business that contribute to your overall success. This may include financial goals, such as revenue targets and profitability metrics, as well as operational goals related to efficiency, scalability, and innovation. Don't forget to set goals for personal and professional development as well, ensuring that you and your partner continue to grow and evolve as business leaders.

Review and Adjust Regularly: Regularly review and adjust your long-term goals to ensure that they remain relevant and aligned with your evolving vision and circumstances. Market conditions, industry trends, and personal priorities may change over time,

requiring you to adapt your goals accordingly. Be flexible and open-minded in your approach, and don't be afraid to pivot or refine your goals as needed.

Communicate and Collaborate: Finally, communicate and collaborate with your partner throughout the goal-setting process. Set aside dedicated time to discuss your long-term goals, share your aspirations and concerns, and co-create a shared vision for your business empire. Collaborative goal-setting strengthens the partnership, fosters alignment, and ensures that both partners are fully invested in the success of the business.

Setting long-term goals for your business empire as a couple is a collaborative and iterative process that requires vision, alignment, and commitment. By defining your vision, identifying core values, setting SMART goals, focusing on growth and impact, balancing short-term and long-term goals, considering different areas of your business, reviewing and adjusting regularly, and communicating and collaborating effectively, you can set a solid foundation for building a successful and fulfilling business together.

Planning for Succession

Planning for succession is an important part of growing a company's empire as a couple. Succession planning is selecting and training individuals to take over important leadership responsibilities within the company in the case of retirement, incapacity, or other unanticipated events. It assures the continuity and long-term viability of the business empire while safeguarding the interests of all stakeholders. As couples embark on a business journey together, succession planning should be included in your overall business strategy from the outset.

Here's a full, complete approach to succession planning:

1. Start Early: Succession planning should ideally begin early in the lifetime of your company's empire, even before the need for succession occurs. Starting early helps you to be proactive in identifying and nurturing possible successors, rather than rushing for replacements after a crisis.

2. Identify prospective successors: Begin by identifying prospective successors, both inside and outside of your business, who possess the abilities, experience, and leadership attributes required to take on crucial responsibilities in the future. Consider individuals on your team who have shown promise for growth and progress, as well as

outsider applicants who may provide new views and experience to the company.

3. Developing Talent: Invest in training, mentoring, and leadership development initiatives to help future successors develop and grow. Provide chances for them to acquire exposure to all sectors of the business while developing the skills and abilities necessary for leadership positions. Encourage continuing learning and development to ensure that future successors are prepared to take on their jobs when the time comes.

4. Create a Succession Plan: Create a detailed succession plan outlining the process of identifying, assessing, and choosing successors to key leadership roles within the corporate empire. Define the criteria and requirements for succession, including the abilities, experience, and leadership qualities necessary for each position. Create a timetable for succession planning activities, and evaluate and revise the plan as appropriate.

5. Communicate Transparently: Communicate your succession plan openly and clearly to important stakeholders, like workers, partners, investors, and family members. Ensure that everyone understands the succession process and criteria, as well as their roles and responsibilities in facilitating the transfer. Create a culture of transparency and openness around succession planning to increase trust and confidence in the process.

6. Document Key Procedures and Knowledge: Document essential processes, procedures, and expertise throughout your company empire to maintain continuity and enable leadership transitions. Create manuals, guidelines, and documentation outlining the primary duties, procedures, and best practices for each job. This documentation will be important to successors when they begin their new responsibilities and will guarantee that critical information is kept inside the business.

7. Addressing Family Dynamics: If your company empire includes family members, your succession planning efforts should take into account the specific dynamics and problems that family-owned enterprises provide. Be proactive in resolving future family tensions, power struggles, and succession difficulties. To successfully manage family dynamics, establish explicit governing structures, communication protocols, and dispute resolution processes.

8. Consider external advisers: Seek the advice and assistance of external advisers, such as legal, financial, and business advisors, in your succession planning activities. External advisers can offer essential experience, insights, and views to help you manage the complexity of succession planning and ensure that your plans are legally and financially sustainable.

9. Test your plan: Periodically test your succession plan using scenario planning and role-playing activities to uncover any possible

gaps or weaknesses. Simulate different succession scenarios and assess the efficacy of your plan in dealing with various obstacles and contingencies. Fine-tune and improve your succession strategy over time using the information gathered from testing.

10. Monitor and review regularly: Monitor your succession plan's development on a regular basis and evaluate it at least once a year to verify that it is still current and effective. Evaluate possible successors' performance and growth, as well as any changes in business goals or market conditions that may affect your succession strategy. Make revisions and updates to your strategy as needed to reflect changing business demands and objectives.

For couples launching a business empire together, succession planning is critical to ensuring the venture's continuity, sustainability, and long-term success. Couples can effectively prepare for the future leadership of their business empire and protect the interests of all stakeholders by starting early, identifying potential successors, developing talent, creating a formal succession plan, communicating transparently, documenting key processes and knowledge, addressing family dynamics, seeking external advisors, testing the plan, and monitoring and reviewing it on a regular basis.

Reflections on Your Journey Together

Reflections on your experience as a pair developing a company empire are critical for personal development, relationship strengthening, and business success. This reflection process entails reflecting on the experiences, struggles, and accomplishments you've experienced as partners in both love and business and extracting useful lessons and insights to guide your future decisions and actions.

Here's a full and complete discussion of reflections on your shared journey:

Gratefulness and Appreciation: Take a minute to show thanks and appreciation for the trip you've been on together. Consider the opportunity to pursue your business aspirations as a pair, as well as the special friendship and collaboration you've developed along the way. Recognize the help, encouragement, and sacrifices you've both made to establish your company empire, and honor your perseverance and dedication to one another.

Lessons Learned: Reflect on the lessons you've learned from your business partnerships. Consider the difficulties you've encountered, the mistakes you've made, and the barriers you've surmounted together. Identify the valuable lessons and wisdom obtained from these experiences and apply them to your future decisions and

activities. Adopt a growth mentality and see setbacks as chances to learn and progress.

Strengths and Weaknesses: Reflect on your particular strengths and limitations as business partners. Consider how your distinct abilities, talents, and viewpoints complement one another and contribute to the success of your company's empire. Determine your strengths and places for improvement. Accept a collaborative approach to exploiting your talents and improving your flaws as a marriage.

Communication and collaboration: Consider how well you communicate and collaborate with your business partners. Consider how well you've talked with one another, addressed problems, and reached choices together. Identify areas of strength in communication and teamwork, as well as areas for improvement. Commit to continual communication and cooperation as critical components of your partnership.

How to Balance Work and Personal Life: As business partners, consider how to strike a balance between your professional and personal lives. Consider how successfully you've handled the challenges of running a business while still prioritizing your relationships and personal well-being. Determine what tactics have helped you maintain balance and where you may need to make

changes. Prioritize self-care and quality time together to achieve a good work-life balance.

Celebrating Milestones: Consider the milestones and accomplishments you've shared during your entrepreneurial journey. Consider the accomplishments, milestones, and progress you've achieved in creating your company's empire. Take pleasure in your successes as a pair and enjoy them together, no matter how large or small.

Adjusting to Change: Consider how adaptable you are as business partners. Consider how successfully you've managed market fluctuations, industry developments, and personal circumstances that have influenced your company's empire. Identify the resilience and flexibility you've shown in the face of change, and adopt a mentality of constant adaptation and creativity as you go.

Shared Vision and Values: Consider how well your shared vision and values align as business partners. Consider how well your vision for the future of your company empire corresponds with your personal beliefs and goals as a marriage. Reaffirm your commitment to your shared vision and values, and use them to guide your decision-making and actions as business partners.

Looking into the Future: Consider your ambitions, desires, and objectives for the future of your business and partnership. Consider the legacy you want to leave, the effect you aim to have on the world, and the goals you want to achieve together. As you continue on your journey together, embrace an optimistic and possibility-filled mindset, knowing that the best is yet to come.

Reflecting on your path as a pair developing a company empire is critical for personal development, relationship strengthening, and commercial success. You can navigate your entrepreneurial journey with confidence, resilience, and purpose as partners in love and business by expressing gratitude and appreciation, learning from your experiences, identifying strengths and weaknesses, prioritizing communication and collaboration, balancing work and personal life, celebrating milestones, adapting to change, reaffirming your shared vision and values, and looking to the future with optimism.

Conclusion

This book is a Comprehensive Guide for Couples Starting a Business Empire" provides a clear and comprehensive blueprint for couples beginning their entrepreneurial adventure together. From establishing the groundwork for their partnership to managing hurdles, setting objectives, and preparing for the future, this guide offers essential insights and practical ideas for creating a successful business empire as a couple.

Throughout the program, couples are encouraged to develop good communication skills, collaborate, and align their objectives and beliefs. They learn the value of balancing work and home life, celebrating accomplishments, and adjusting to change as they traverse the ups and downs of business together.

Couples may create a robust, sustainable, and rewarding business empire by reflecting on their path, embracing development, learning from obstacles, and nourishing their relationship along the way. Couples may overcome barriers, grasp opportunities, and realize their business aspirations together if they are dedicated, persistent, and committed to cooperation.

This book is a complete resource and companion for couples as they start on the thrilling and transforming path of establishing a business empire together. It demonstrates the power of love, teamwork, and shared goals to achieve success and fulfillment in business and life.

www.ingramcontent.com/pod-product-compliance
Lightning Source LLC
Chambersburg PA
CBHW071924210526
45479CB00002B/546